# BECOMING BRAVE

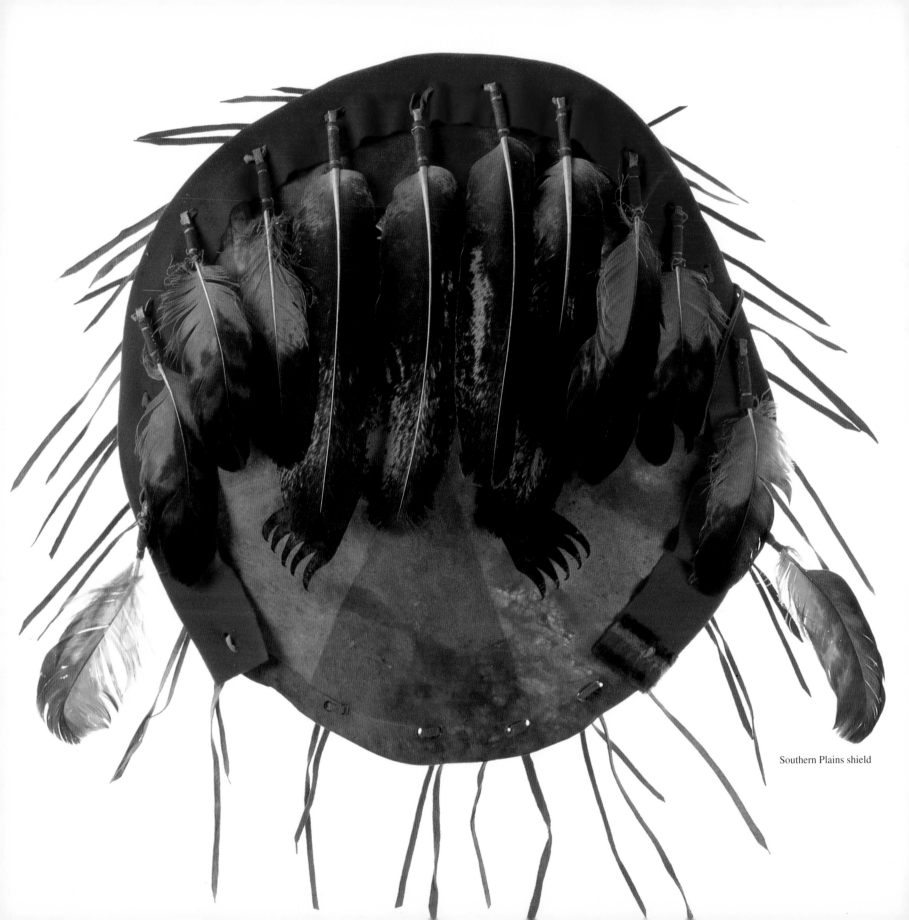

Southern Plains shield

"The first thing I can remember is my father telling me about war. We then lived in tepees like the one in which we are now sitting. We were then moving from place to place, and the old people were constantly talking about war. That was the school in which I was brought up — a war school. We kept on moving from place to place until I grew to manhood. Then I came to see a real battle. The first time I was in a battle I thought of what my father had told me. He told me to be a brave man and fight and never run away. I think this was good fighting, because I know what fighting meant from what my father had told me. At that time if an Indian wanted to win distinction he must be a good man as well as a good fighter."

—Chief Apache John at the Last Great Indian Council in 1914.

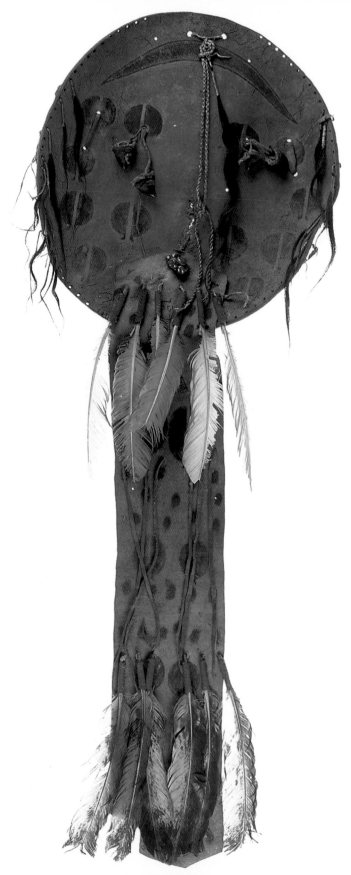

Sioux shield

# BECOMING BRAVE

## THE PATH TO NATIVE AMERICAN MANHOOD

Introduction and Captions by Laine Thom
Designed and Produced by McQuiston & Partners
Chronicle Books • San Francisco

*To my great uncle Arthur Johnson, who I call my grandfather, and to all Native American veterans who were warriors in their time.*

I would like to acknowledge Sharlene Milligan, Executive Director, Grand Teton Natural History Association; Bill Swift, Chief Naturalist; C. J. Brafford, Head Curator; and the Ranger Naturalist staff at Colter Bay Indian Arts Museum at Grand Teton National Park, Wyoming. Special thanks go to Grace Johnson, Assistant Curator at the San Diego Museum of Man, for her patience and cheerfulness while helping us select many of the artifacts and historical images in this book, and also Stefani Salkeld, Ken Hedges, Chris Bentley, and all the staff at the San Diego Museum of Man. Many thanks to Jack Jensen, Lesley Bruynesteyn, and Michael Carabetta of Chronicle Books for their continual support, and to Joyce Sweet and Don McQuiston for inviting me to participate in this project. I would like to acknowledge Linda Harrelson for her time and her thoughts in helping me with the introduction to this book, and Jay Trowbridge for advising me on certain tribal customs.

—Laine Thom

Produced by McQuiston & Partners, Del Mar, California; art direction by Don McQuiston; design by Don McQuiston & Joyce Sweet; editing by Julie Olfe; artifact photography by John Oldenkamp, Carin Howard, and Cynthia Sabransky. Printed in Hong Kong.

Library of Congress Cataloging-in-Publication Data
Becoming brave: the path to Native American manhood/introductory material and pictorial commentary by Laine Thom.
    p.    cm.
    Includes index
    1. Indians of North America—Great Plains—Social life and customs. 2. Indians of North America—Great Plains—Material culture. 3. Indians of North America—Great Plains—Social life and customs—Pictorial works. 4. Indians of North America—Great Plains—Material culture—Pictorial works. I. Thom, Laine, 1952-
E78.G73B43    1992    92-1006
978'.00497—dc20  CIP
ISBN 0-8118-0219-1.
ISBN 0-8118-0163-2  (pbk.)
10  9  8  7  6  5  4  3  2

Distributed in Canada by Raincoast Books
112 East Third Avenue
Vancouver, British Columbia V5T IC8

Chronicle Books
275 Fifth Street
San Francisco, California 94103

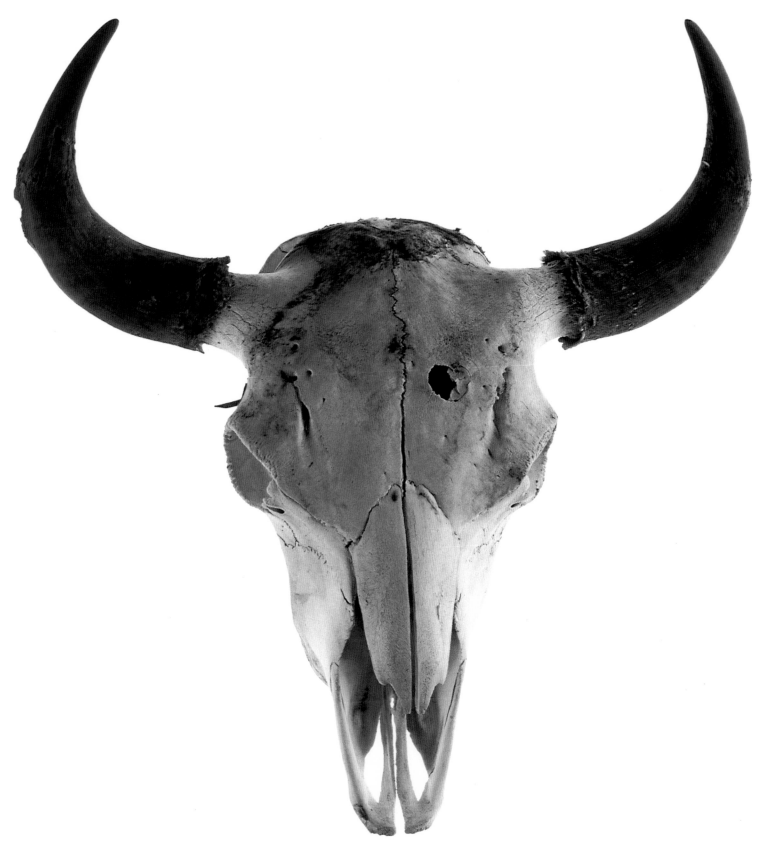

Buffalo skull

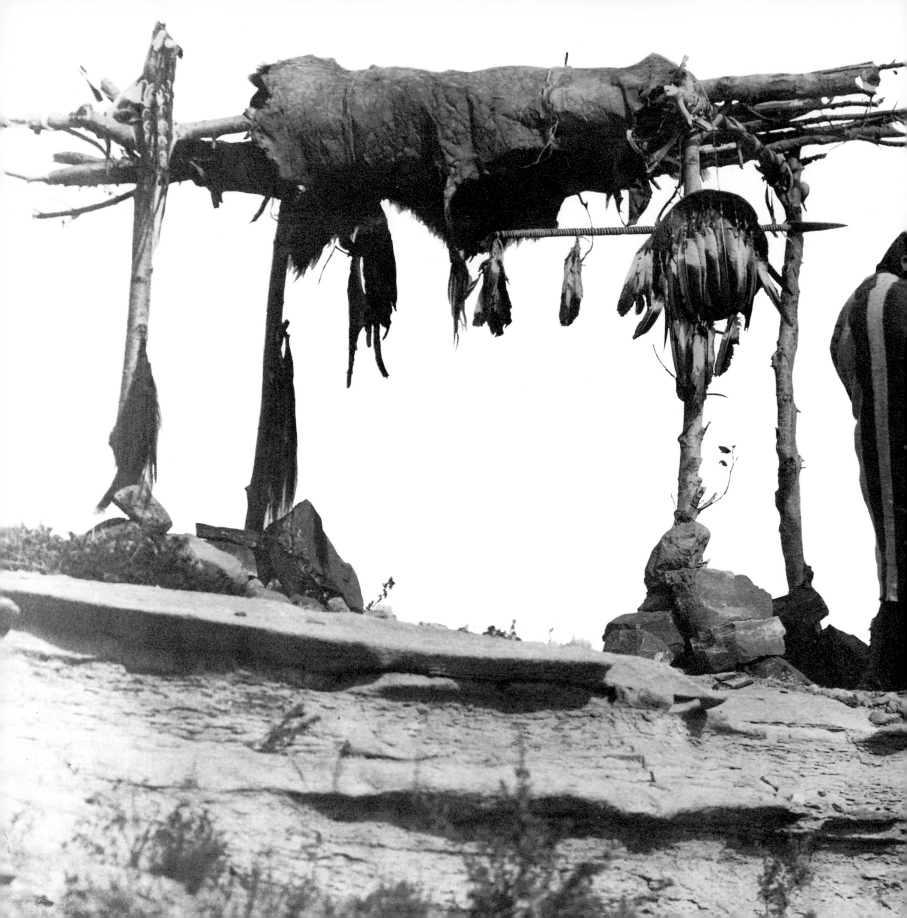

CONTENTS

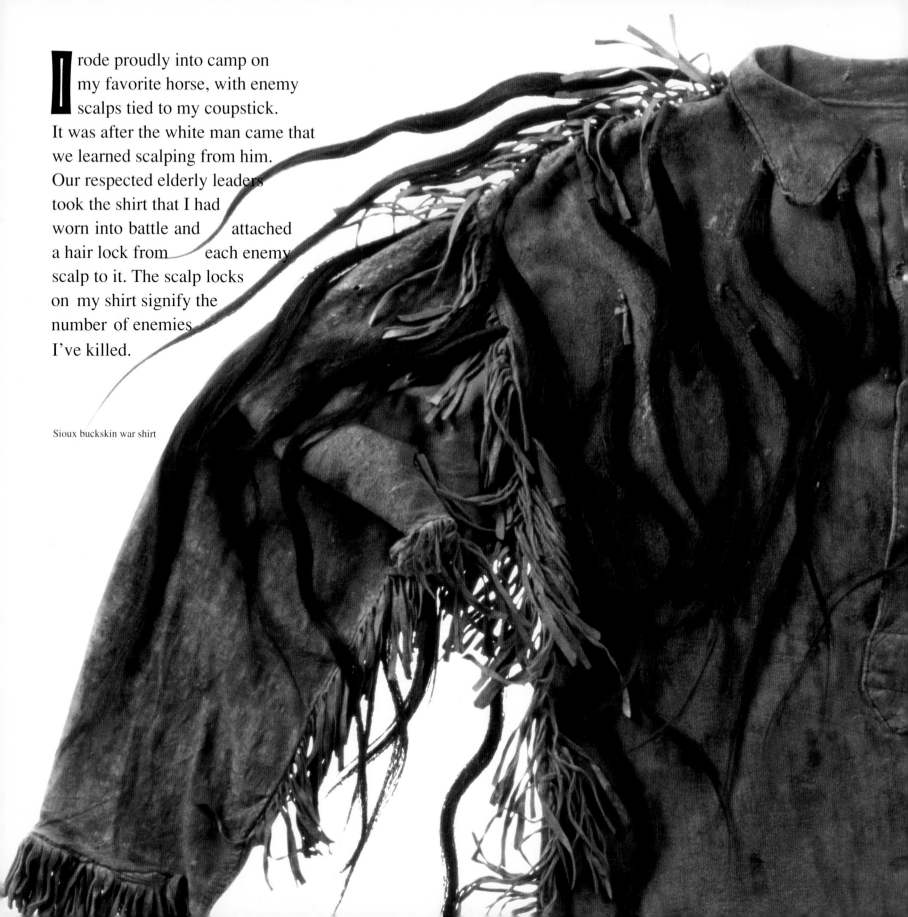

I rode proudly into camp on my favorite horse, with enemy scalps tied to my coupstick. It was after the white man came that we learned scalping from him. Our respected elderly leaders took the shirt that I had worn into battle and attached a hair lock from each enemy scalp to it. The scalp locks on my shirt signify the number of enemies I've killed.

Sioux buckskin war shirt

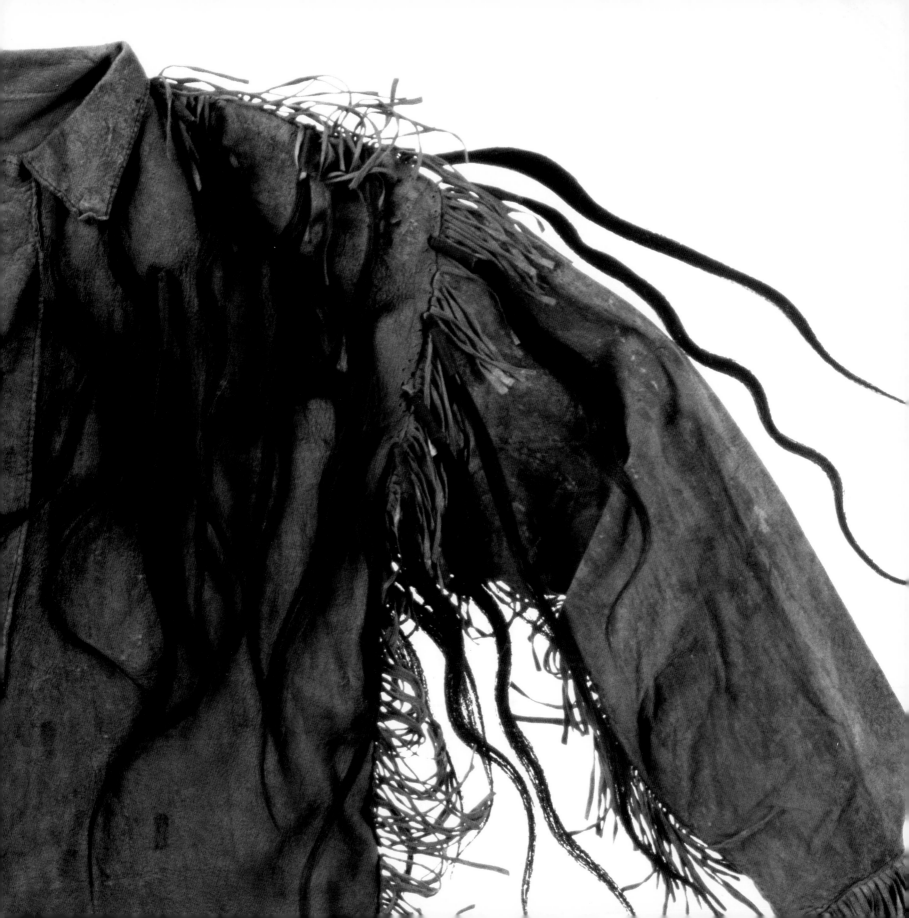

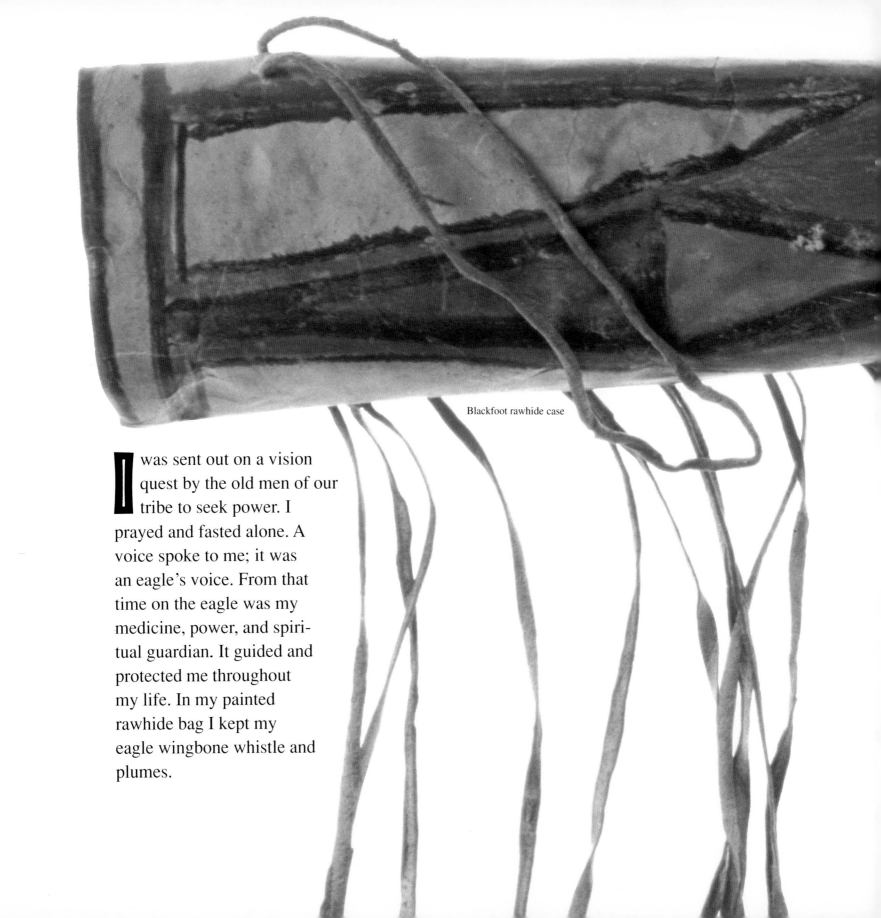

Blackfoot rawhide case

I was sent out on a vision quest by the old men of our tribe to seek power. I prayed and fasted alone. A voice spoke to me; it was an eagle's voice. From that time on the eagle was my medicine, power, and spiritual guardian. It guided and protected me throughout my life. In my painted rawhide bag I kept my eagle wingbone whistle and plumes.

Crow shield

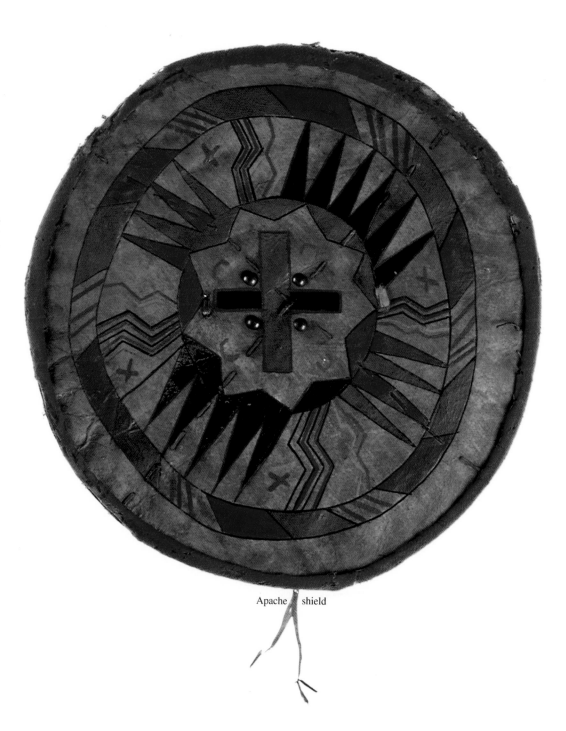

I start with a round piece of rawhide from the hump of a buffalo. To toughen the rawhide, I put it over heated rocks. It becomes my shield, with red or navy blue trade cloth around the edges. The spirit of a bird or animal will give me power and protect me from enemy arrows when I go into battle.

Apache shield

# AN UNENDING CYCLE

## INTRODUCTION

*Sacred water: it is my
grandmother, giver of life.*

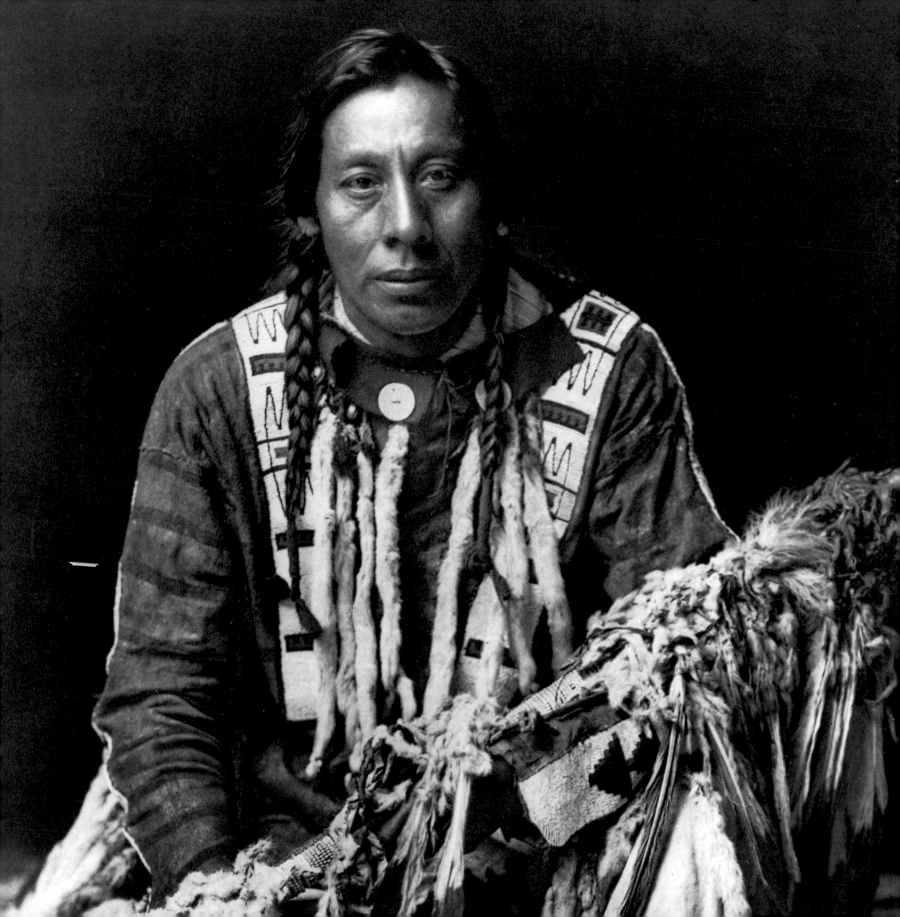

# AN UNENDING CYCLE: INTRODUCTION

*By Laine Thom*

〰〰〰〰〰

*I am descended from three tribes: the Shoshone, Goshiute, and Paiute. I am what is known by many tribes as an old people's child because I spent much of my childhood with the elders. I was brought up to respect the earth, nature, elders, and myself. I was brought up to listen, practice, and carry on the tribal customs and traditions they left me. At age four I was given a legendary name by my great-grandmother. She called me Tu-wah-oz, child of the stars, a brother to the seven sisters, the stars.*

In the Indian world, all aspects of a man's direction in life are passed from person to person and generation to generation through consistent, detailed, oral history and repeated ritual. An unending cycle.

When a boy is born he is immersed in water to cleanse his new body. This gives him a taste of water that will nourish his body for his journey through life. His umbilical cord is stored in a turtle-shaped amulet. The turtle lives a long life, therefore using its form symbolically assures this boy a long existence. This amulet is hung from his cradleboard, which will be his home until he releases himself from its bindings.

As a young boy he takes direction from the old ones. He runs errands and performs small tasks for them. In return, they craft miniature weapons for him to play with. The elders also tell him stories of the beginnings of his people. The morals of these stories help to shape his character, and the stories are used as disciplinary tools instead of physical punishment. His religious

*A Piegan warrior with his medicine pipe.*

discipline is introduced early, since daily family life and religion are closely intertwined.

In play, he hunts small game such as squirrels, rabbits, sage hens, and grouse. He learns how to use feathers and other animal parts to fashion warfare accoutrements.

His early childhood lessons learned, the boy is put to the test. He is given his first major responsibility: to care for the horses. The horse is held in high esteem for its part in survival. As a measure of wealth, it determines social standing. Mystical qualities are also attributed to it. Under supervision, the boy is shown how to water, graze, and guard the herd. After he has learned to respect their supernatural power and their worth, he is given his first horse.

Now he spends his time training his horse to respond to his signals and commands. This includes teaching the horse to dance and strut. This will be helpful in the future, for in battle, a still-standing horse and its rider are easy targets that draw enemy fire.

Now is his time to become an active participant in his spiritual path. Up until now he has been a spectator and observer at the religious ceremonies. Alone, or perhaps with childhood friends, he prepares for a vision quest. Although they may prepare together, each must seek his vision alone. Again the elders direct and outline every aspect. The boy is purified in a sweatbath and instructed in prayer. Vision quest is undertaken for numerous reasons. He may want medicine power to protect him and make him successful in battle. He may be in search of power to use for curative or healing purposes. Or he may be seeking the answer to a question.

After the sweatbath, he sets out for a remote area in the mountains or hills. He will fast for four days and nights unless his vision is more quickly revealed. These days and nights are spent in prayer and meditation until he is visited by his spiritual guardian, or medicine. The guardian can take the form of many things — bird, animal, tree, water, rock, or dream. This guardian will speak to him and reveal its powers.

Having completed his journey and fulfilled his quest, the boy returns to be met by his elders. He is again purified, and relates his experience. This will be the only time he speaks of it. He is shown how to care for his medicine, for he will incorporate it into a later phase of his life.

From the mock hunting of his play he is now ready to prepare for his first hunt. He is taught to knap his arrowheads and spearpoints of obsidian, to choose the proper willows for the shafts, and to choose the proper feathers for fletching. He makes sinew-backed bows of juniper, mountain mahogany, and horns from the bighorn sheep. For big game he makes spears and lances.

With his first bow and arrows he makes his first big kill. The kill is donated and distributed to the elderly and needy people of the tribe. This helps to instill the values of sharing and generosity, and is also a thankful gesture for the knowledge given. Each major hunt is well orchestrated in advance. Every man knows how important his and his horse's roles are. If the Indians are near buffalo jump areas they make use of them. The successful end result is an abundant supply of food and materials for home and clothing.

Up until now, the young man hasn't had a need for personal material wealth. He will now work toward that goal. Obtaining horses from enemy tribes is a way to obtain wealth, and it also serves to elevate his tribal standing. On horse raids he carries his personal medicine as protection. Perhaps he may affix it to his rawhide shield. Under the guidance and advice of an older and experienced warrior, he sets out with a small raiding party. They ride at night. After scouting the situation and noting the movements in the enemy camp, they attack at dawn. While the enemy sleeps they creep into the herd, and each man captures several horses, riding one and leading the others. A successful raid is celebrated by song and dance after arrival in camp.

Should a horse raid end with a man being killed, the warriors will prepare for battle to retaliate for the death. Since the men have prepared for warfare from adolescence, they are enthusiastic about the opportunity to gain credit and renown in battle. An unexcelled war record and outstanding bravery are rewarded with prestige and an opportunity for leadership and a voice

in council decisions. As honors for his deeds in battle and his efforts on his people's behalf, a warrior is awarded eagle feathers. He wears them whenever he dresses in his finery.

The warriors are armed with bows and arrows, lances, war clubs, and shields. The bravest act that can be performed is actual personal contact with the enemy by touching him with a bare hand, or with something held in the hand. In this way a warrior counts coup. Another way to count coup is to be the first one to touch an enemy who has just been killed.

The warrior also takes enemy scalps, a practice learned from the eastern tribes who in turn learned the practice from the French. After the battle he rides into camp with the scalps displayed on his lance. Some of these scalps are later used to decorate his lodge and clothing. The rest are taken into the mountains to be left with a prayer offering.

Should he choose, perhaps he may take on the added responsibilities of a wife and beginning a family. Then in addition to being a warrior, he becomes a provider and protector.

When he becomes an elderly man, he reflects and remembers the fellow warriors of his boyhood. Some have fallen in battle, some have passed on from sickness or old age, and some have succumbed to the elements of nature. He spends his time advising and guiding the young boys, helping them to master the lessons he has learned.

He no longer participates in the horse raids and battles, for he is now a leader and an adviser. He helps to celebrate the accomplishments of the young warriors who return from successful expeditions. He dresses in deerskin shirts decorated with the scalplock trophies of his warrior days, and wears his warbonnet of eagle feathers that signify his bravery and accomplishments. He now dons his finest, not for himself, but to honor and show respect for his people.

The cycle continues.

*A Flathead dance.*

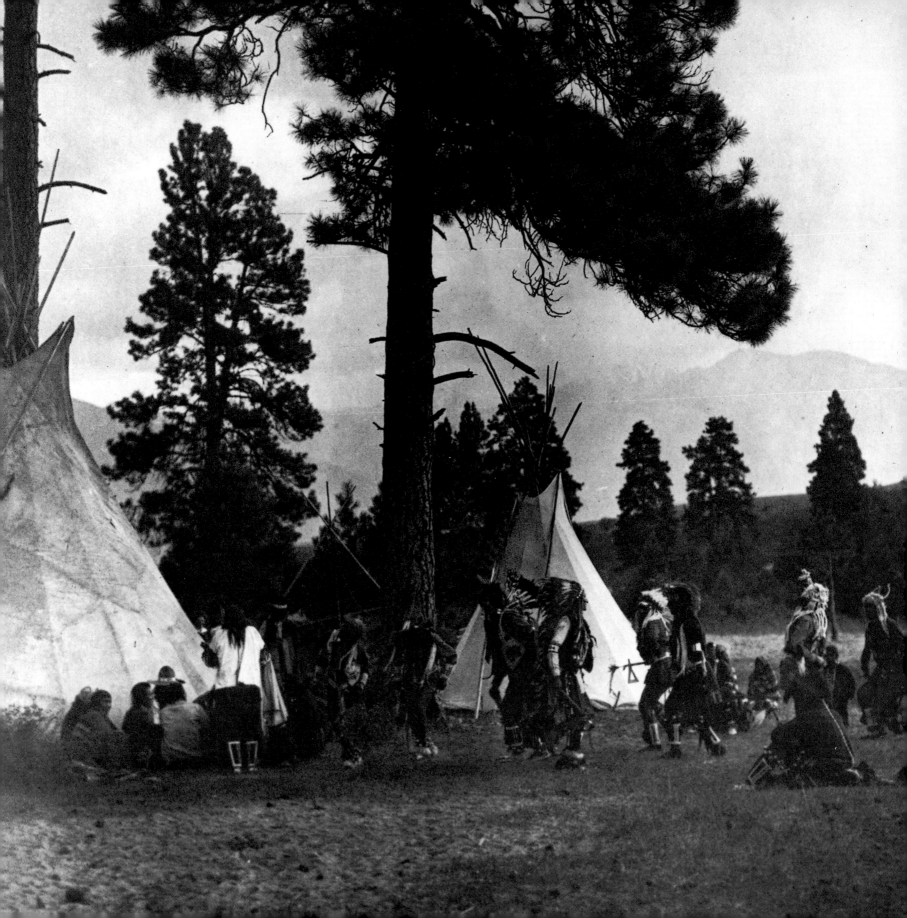

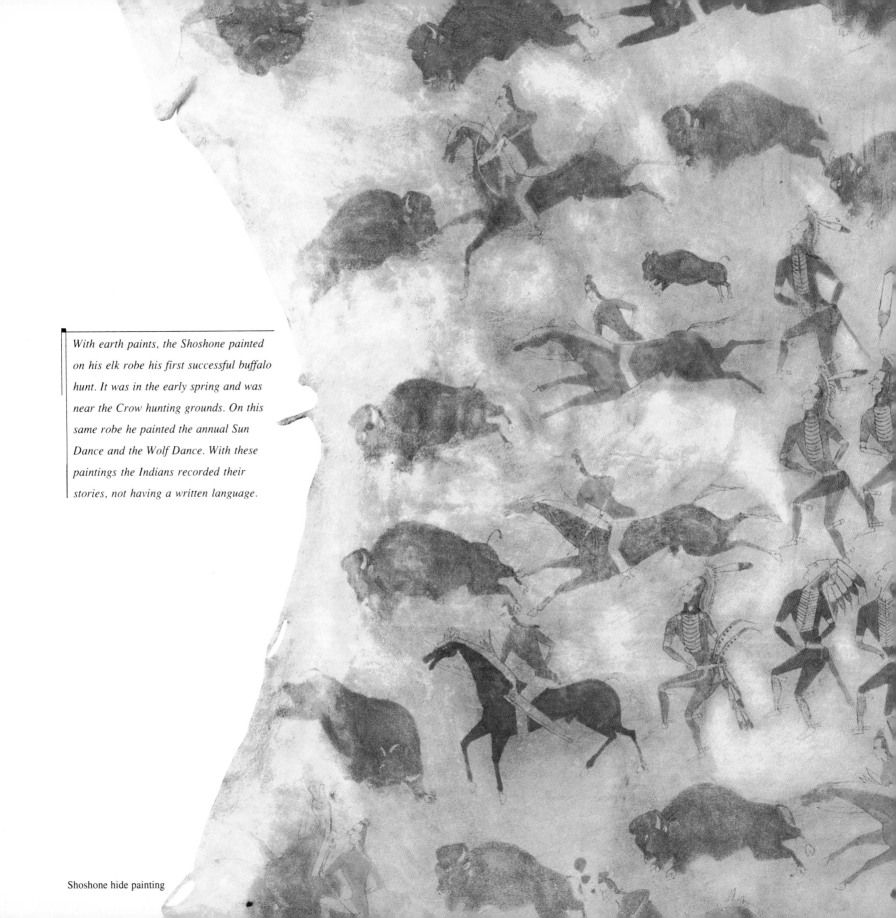

*With earth paints, the Shoshone painted on his elk robe his first successful buffalo hunt. It was in the early spring and was near the Crow hunting grounds. On this same robe he painted the annual Sun Dance and the Wolf Dance. With these paintings the Indians recorded their stories, not having a written language.*

Shoshone hide painting

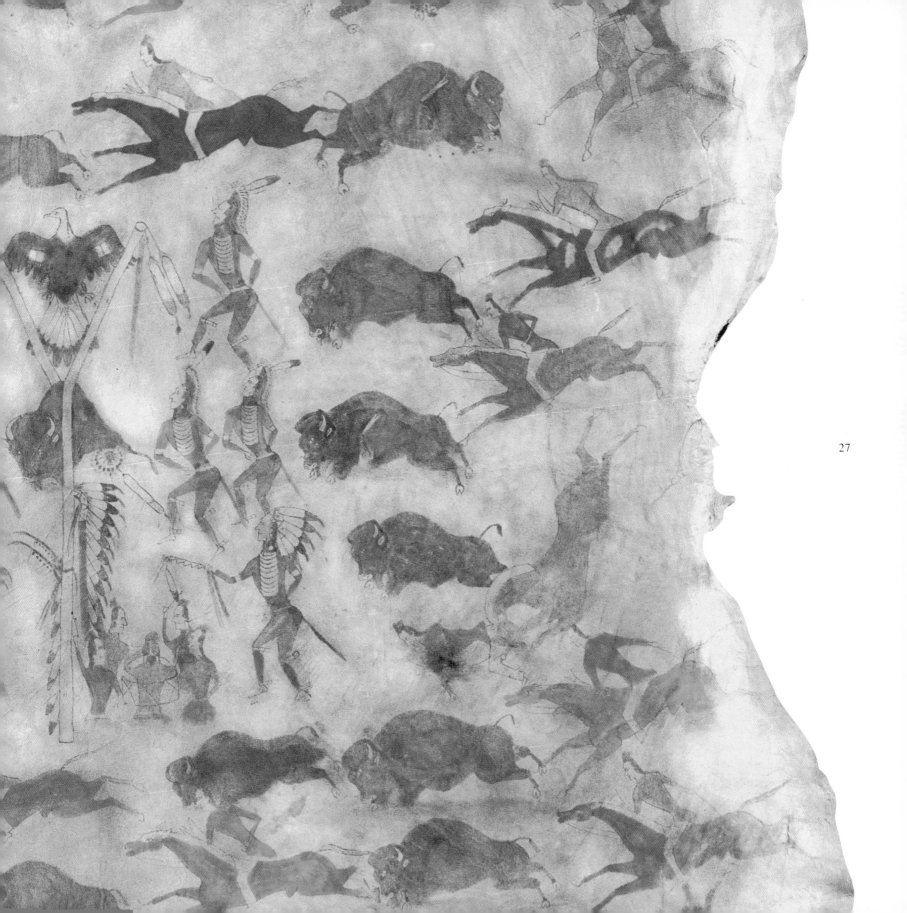

O vanished buffalo, you were truly a gift from the Great Spirit; you sacrificed your life that we may live. Your flesh was our food, your skin our clothing and our dwelling place. After you were gone your spirit came back as a messenger from the Great Spirit to grant our people good health, happiness, and long life. Once again we use your skull in our sacred Sun Dance.

29

# THE BISON HUNT

*O Father Sun, guardian of*
*the day, divine healer!*

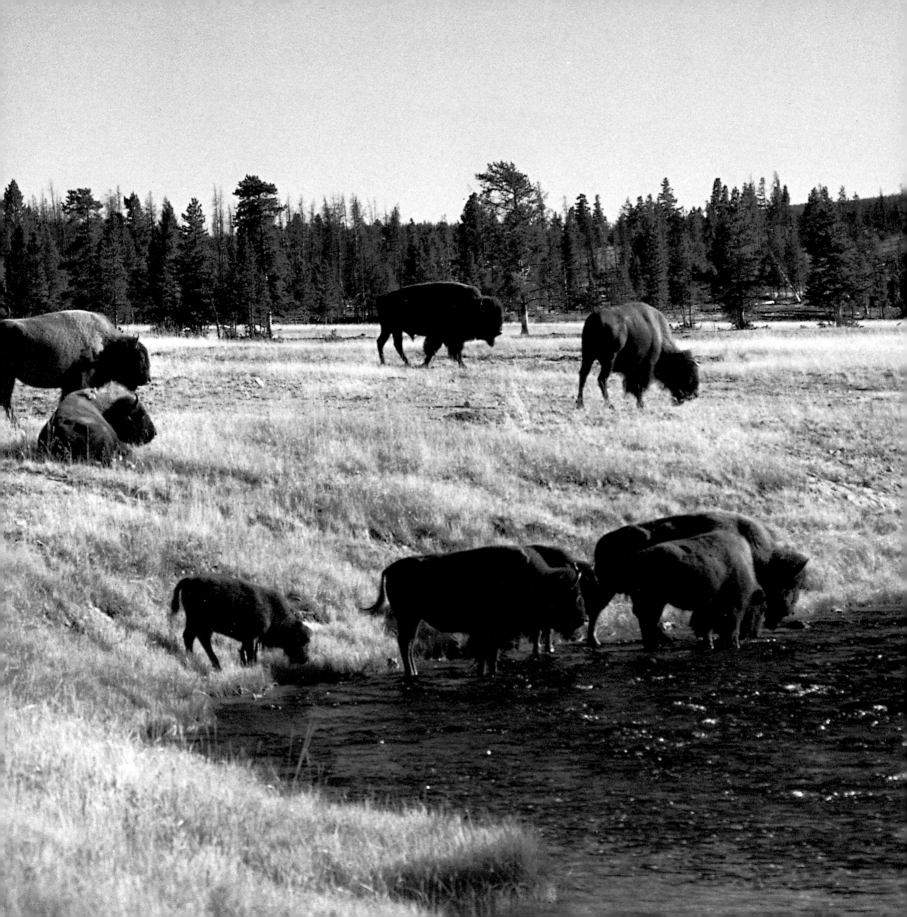

# T H E
# B I S O N   H U N T

ᨈᨈᨈᨈᨈᨈᨈ
‾‾‾‾‾‾‾

*The buffalo was a gift of love from the Great Spirit to his red children. The Plains Indians depended upon the buffalo for their everyday life. All parts of this wonderful animal were used; nothing was wasted. Skins were made into tipis, clothing, robes, and rawhide bags called parfleches. The meat, liver, and lungs were their food; the heart was eaten raw immediately after the hunter made his kill. Black Elk was a holy man among the Oglala Sioux tribe. He was born in the Moon of the Popping Trees (December) in 1863. As a young man Black Elk had a great vision about the powers of the world; he dreamed that his people would live in cosmologic balance with earth. He died in 1950 on the Pine Ridge Indian Reservation in South Dakota.*

One morning the crier came around the circle of the village calling out that we were going to break camp. The advisers were in the council tepee and he cried to them: "The advisers, come forth to the center and bring your fires along." It was their duty to save fire for the people, because we had no matches then.

"Now take it down, down!" the crier shouted. And all the people began taking down their tepees, and packing them on pony drags.

Then the crier said: "Many bison, I have heard; many bison, I have heard! Your children, you must take care of them!" He meant to keep the children close while traveling, so that they would not scare the bison.

Then we broke camp and started in formation, the four advisers first, a crier behind them, the chiefs next, and then the people with the loaded pony drags in a long line, and the herd of ponies following. I was riding near the

*Brother Buffalo and Grandmother Water come together to sing the song of life.*

rear with some of the smaller boys, and when the people were going up a long hill, I looked ahead and it made me feel queer again for a little while, because I remembered the nation walking in a sacred manner on the red road in my vision. But this was different, and I forgot about it soon, for something exciting was going to happen, and even the ponies seemed to know.

After we had been traveling awhile, we came to a place where there were many turnips growing, and the crier said: "Take off your loads and let your horses rest. Take your sticks and dig turnips for yourselves." And while the people were doing this, the advisers sat on a hill nearby and smoked. Then the crier shouted: "Put on your loads!" and soon the village was moving again.

When the sun was high, the advisers found a place to camp where there was wood and also water; and while the women were cooking all around the circle I heard people saying that the scouts were returning, and over the top of a hill I saw three horsebacks coming. They rode to the council tepee in the middle of the village and all the people were going there to hear. I went there too and got up close so that I could look in between the legs of the men. The crier came out of the council tepee and said, speaking to the people for the scouts: "I have protected you; in return you shall give me many gifts." The scouts then sat down before the door of the tepee and one of the advisers filled the sacred pipe with chacun sha sha, the bark of the red willow, and set it on a bison chip in front of him, because the bison was sacred and gave us both food and shelter. Then he lit the pipe, offered it to the four quarters, to the Spirit above and to Mother Earth, and passing it to the scouts he said: "The nation has depended upon you. Whatever you have seen, maybe it is for the good of the people you have seen." The scouts smoked, meaning that they would tell the truth. Then the adviser said: "At what place have you stood and seen the good? Report it to me and I will be glad."

One of the scouts answered: "You know where we started from. We went and reached the top of a hill and there we saw a small herd of bison." He pointed as he spoke.

on our bellies, and when we got back without getting caught, we would have a big feast and a dance and make kill talks, telling of our brave deeds like warriors. Once, I remember, I had no brave deed to tell. I crawled up to a leaning tree beside a tepee and there was meat hanging on the limbs. I wanted a tongue I saw up there in the moonlight, so I climbed up. But just as I was about to reach it, the man in the tepee yelled "Ye-a-a!" He was saying this to his dog, who was stealing some meat too, but I thought the man had seen me, and I was so scared I fell out of the tree and ran away crying.

Then we used to have what we called a chapped breast dance. Our adviser would look us over to see whose breast was burned most from not having it covered with the robe we wore; and the boy chosen would lead the dance while we all sang like this:

"I have a chapped breast.

My breast is red.

My breast is yellow."

And we practiced endurance too. Our adviser would put dry sunflower seeds on our wrists. These were lit at the top, and we had to let them burn clear down to the skin. They hurt and made sores, but if we knocked them off or cried Owh!, we would be called women.

37

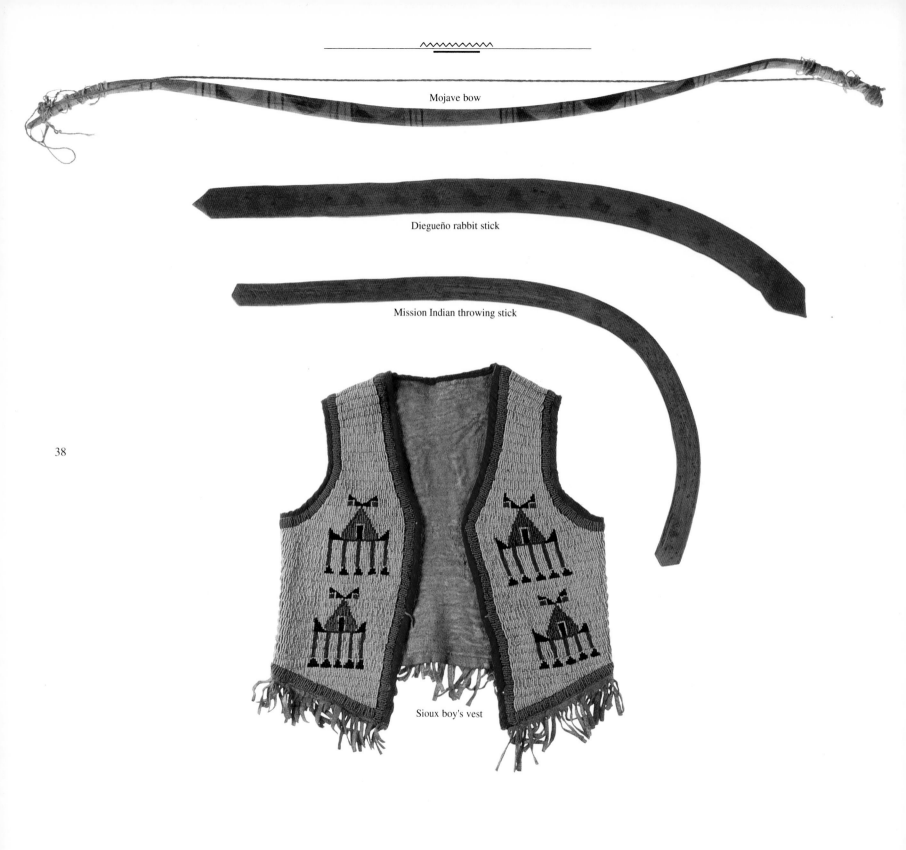

Mojave bow

Dieguéño rabbit stick

Mission Indian throwing stick

38

Sioux boy's vest

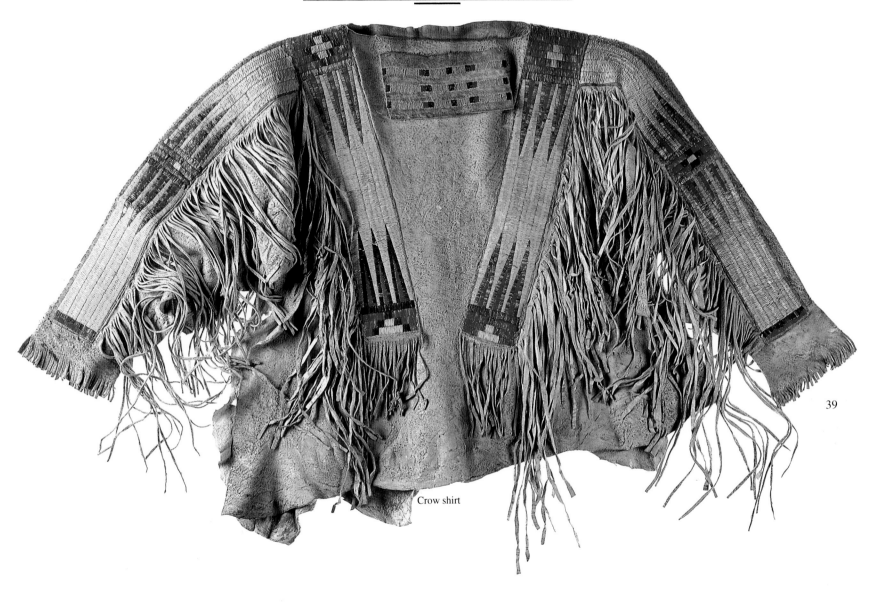

Crow shirt

*A child learned at a very early age by observing, listening, and imitating in his play what he had seen, whether it was a hunt or a battle. Bows and arrows and throwing sticks were made for him to learn from. And, like his father and grandfather, on very special occasions he wore a fully beaded vest (opposite). The man's shirt above is decorated with porcupine quills dyed yellow, purple, and red, and with very little beadwork. It is a fine example of a pre–Reservation Period shirt.*

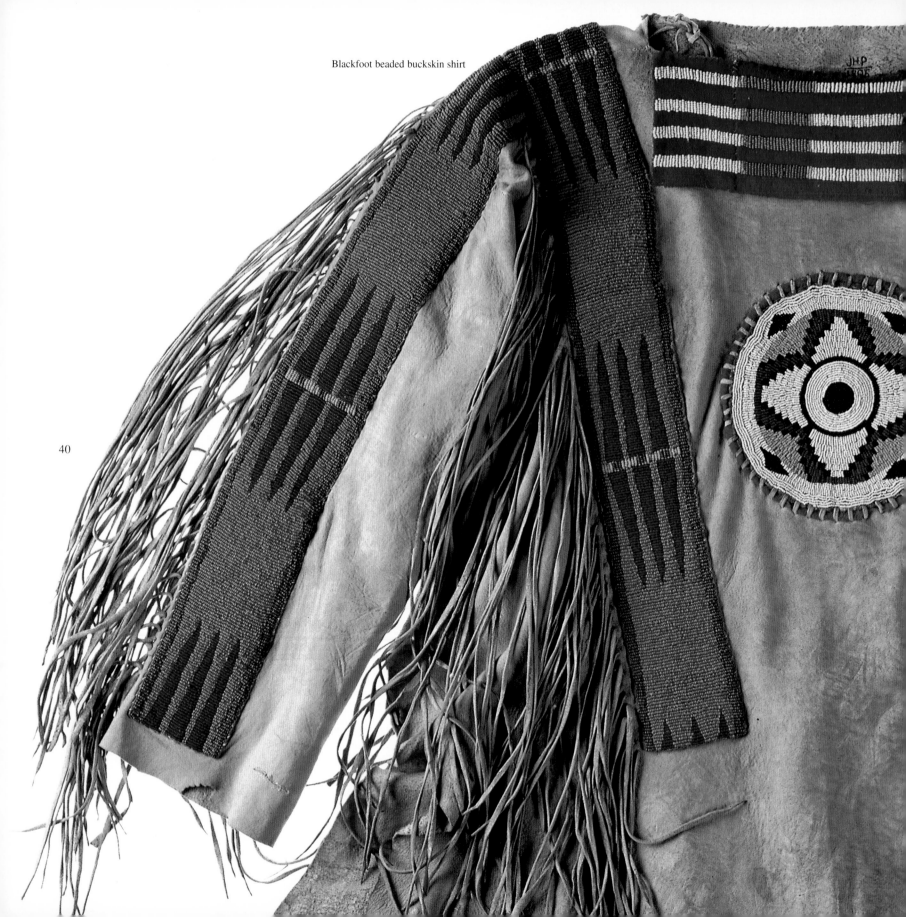

Blackfoot beaded buckskin shirt

40

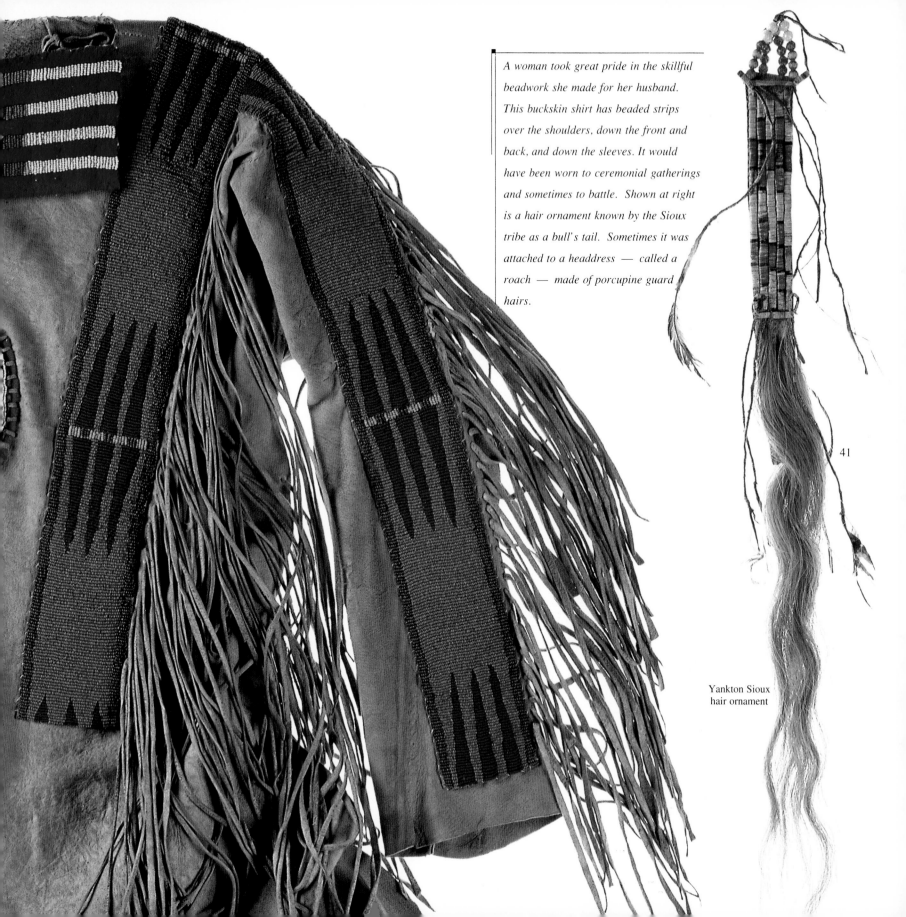

A woman took great pride in the skillful beadwork she made for her husband. This buckskin shirt has beaded strips over the shoulders, down the front and back, and down the sleeves. It would have been worn to ceremonial gatherings and sometimes to battle. Shown at right is a hair ornament known by the Sioux tribe as a bull's tail. Sometimes it was attached to a headdress — called a roach — made of porcupine guard hairs.

41

Yankton Sioux
hair ornament

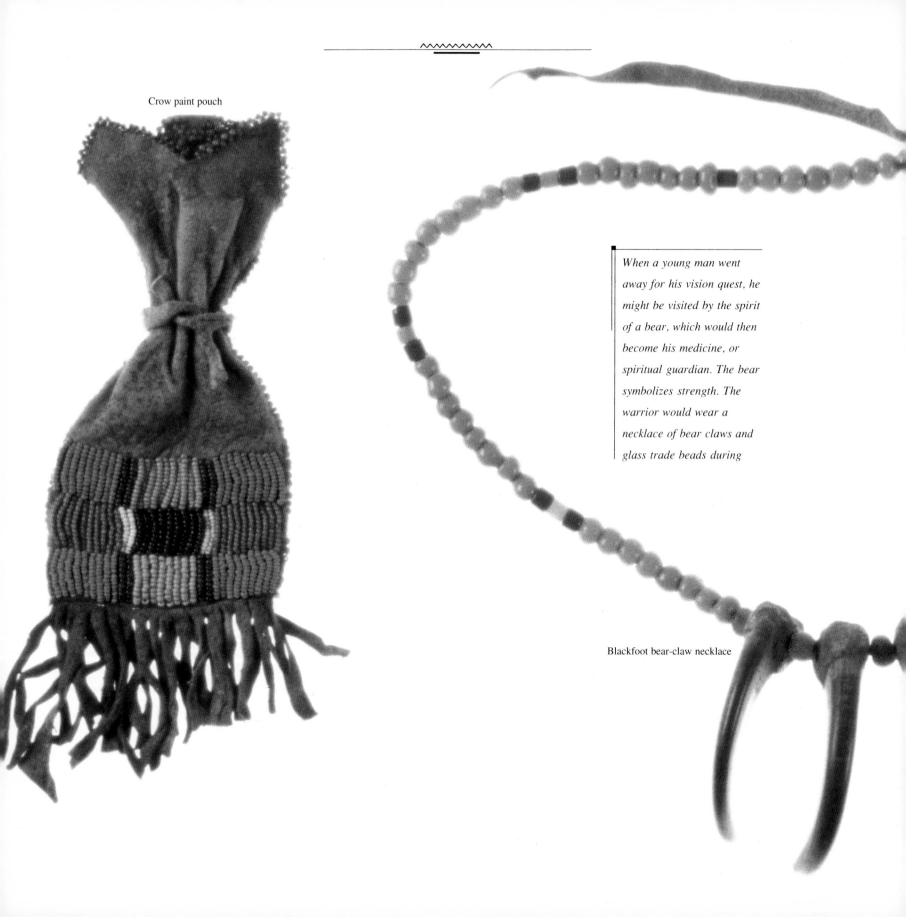

Crow paint pouch

Blackfoot bear-claw necklace

*When a young man went away for his vision quest, he might be visited by the spirit of a bear, which would then become his medicine, or spiritual guardian. The bear symbolizes strength. The warrior would wear a necklace of bear claws and glass trade beads during*

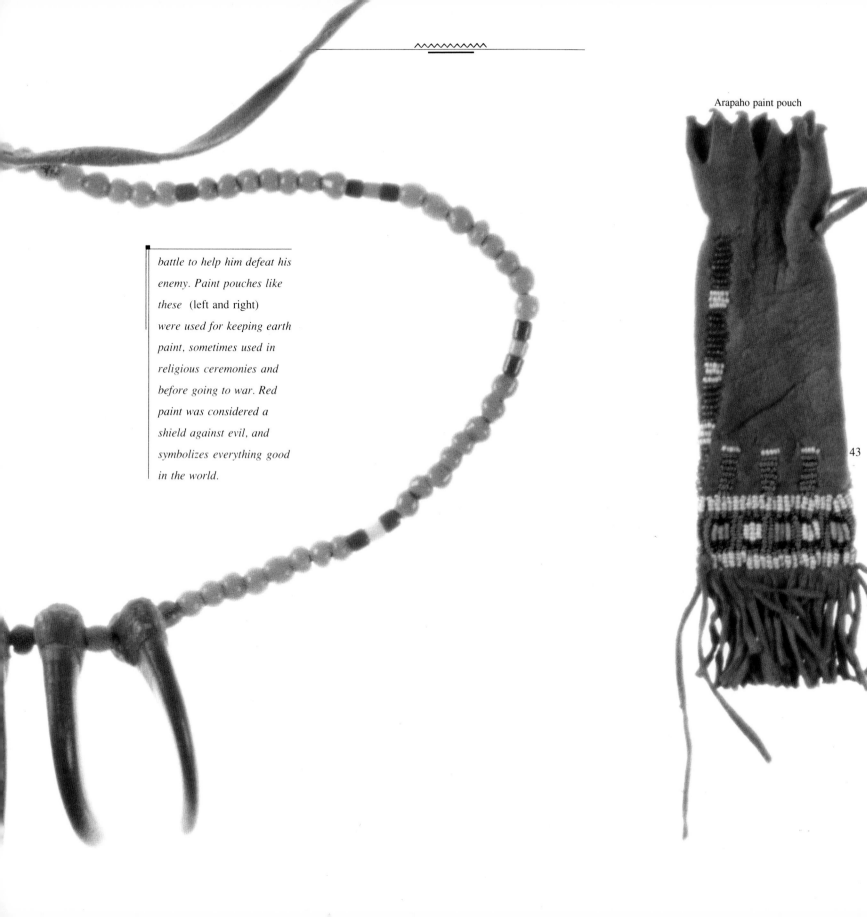

battle to help him defeat his enemy. Paint pouches like these (left and right) were used for keeping earth paint, sometimes used in religious ceremonies and before going to war. Red paint was considered a shield against evil, and symbolizes everything good in the world.

Arapaho paint pouch

43

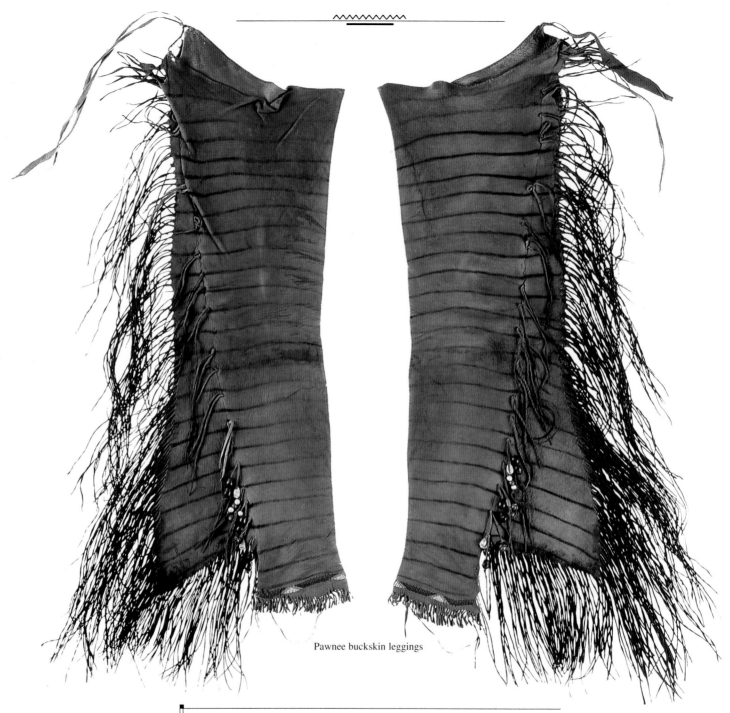

Pawnee buckskin leggings

44

*The Plains Indian man's everyday attire was pair of moccasins, leggings, and a breechcloth. Leggings were worn like chaps. Two tanned hides were needed to make a pair of leggings from elk, deer, or antelope. The animal skins were folded in half lengthwise, tied or sewn along the side, then fringed. Among some of the southern Plains tribes, leggings were painted yellow, and the*

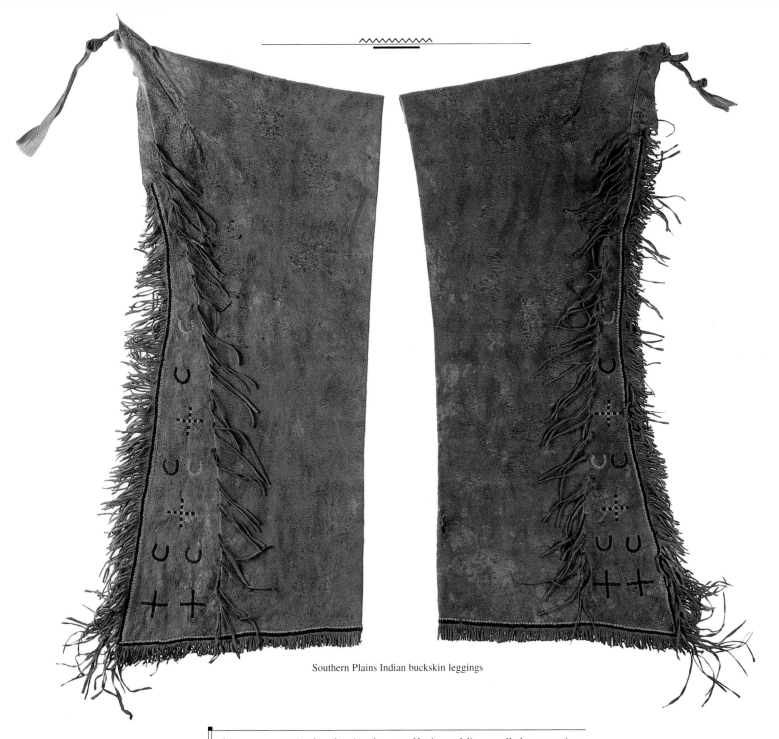

Southern Plains Indian buckskin leggings

*fringes were twined and painted green. Horizontal lines, called coup stripes, were painted down each leg to mark the wearer's bravery and honor. If the warrior had been successful in horse raids, horse-hoof motifs were painted or beaded along each side of the leggings.*

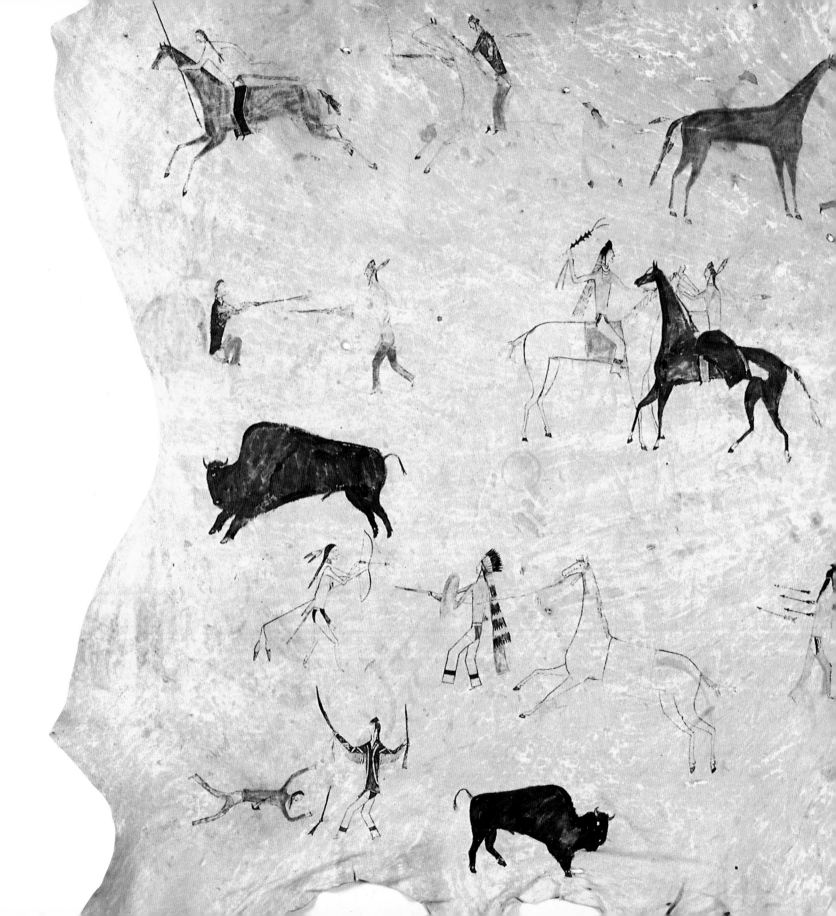

46

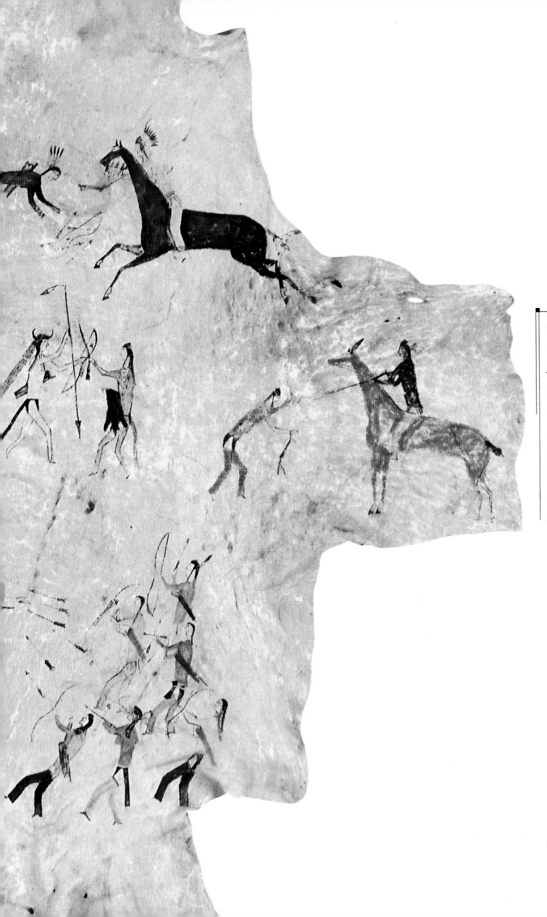

After its arrival with the Spaniards, the horse spread north and south, more through trade than raids — first from the Comanches to the Shoshones, then from the Shoshones to the Crow, Nez Perce, and Flathead tribes. After 1750 most Plains Indian tribes had horses. Then came horse raids, which caused war among tribes, as shown on this hide painting. The men were great and daring horsemen. To have large numbers of horses was a symbol of wealth and prestige.

47

Shoshone painted elk hide

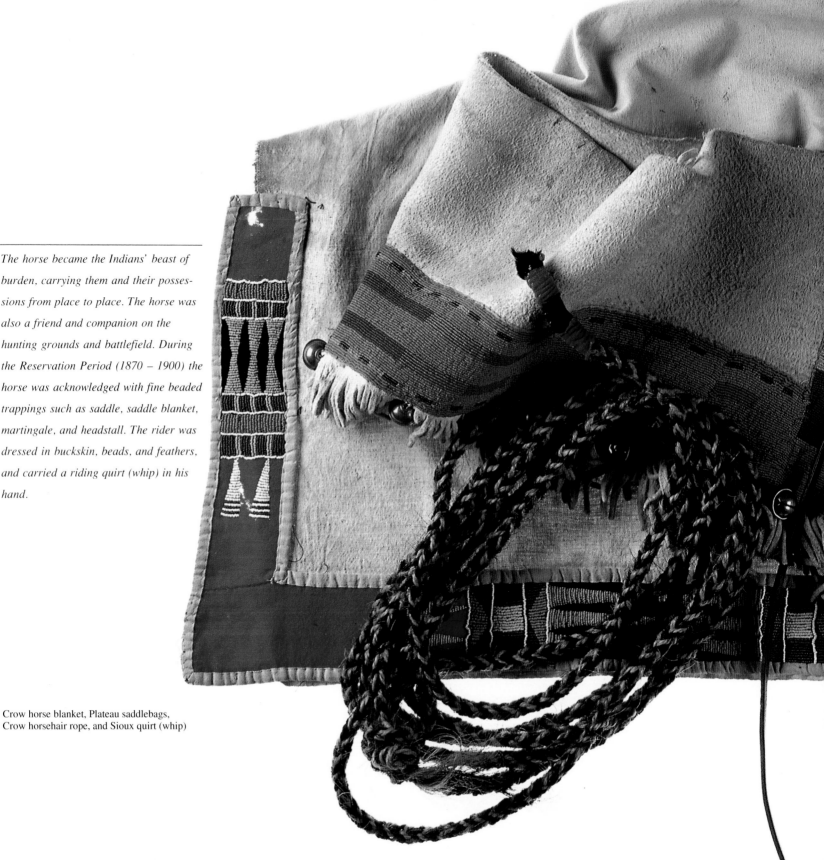

The horse became the Indians' beast of burden, carrying them and their possessions from place to place. The horse was also a friend and companion on the hunting grounds and battlefield. During the Reservation Period (1870 – 1900) the horse was acknowledged with fine beaded trappings such as saddle, saddle blanket, martingale, and headstall. The rider was dressed in buckskin, beads, and feathers, and carried a riding quirt (whip) in his hand.

Crow horse blanket, Plateau saddlebags,
Crow horsehair rope, and Sioux quirt (whip)

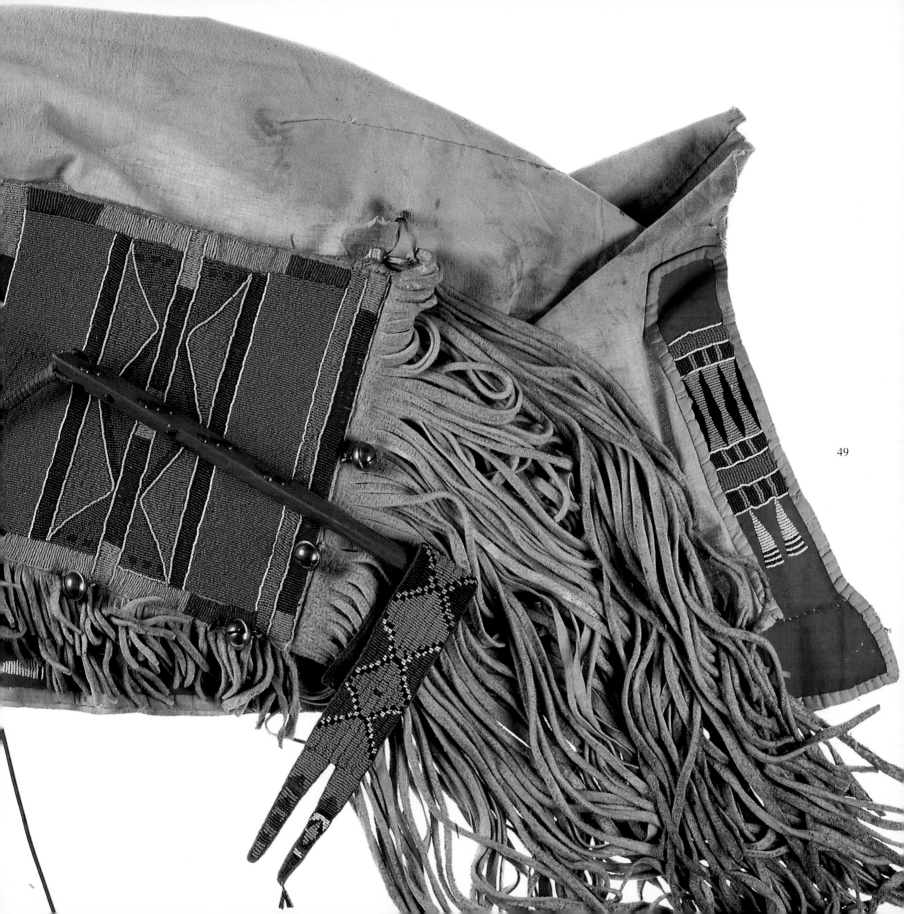

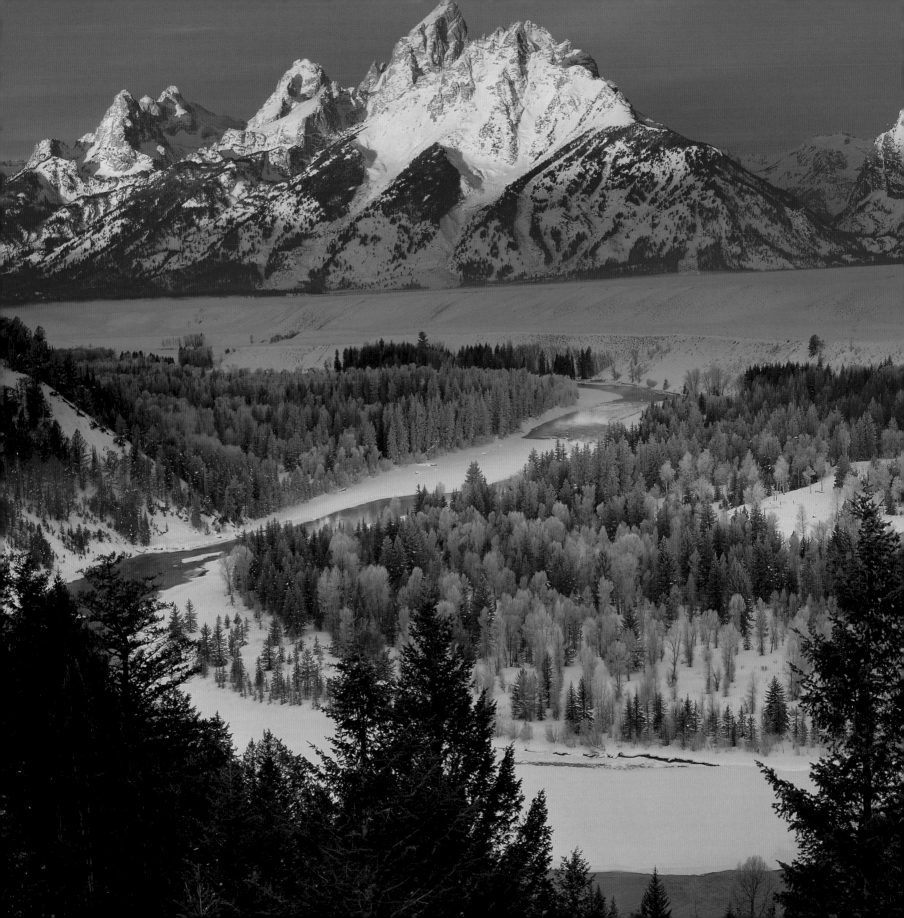

# THE WAR TRAIL

*Mountains and rocks are*
*the source of spiritual power.*

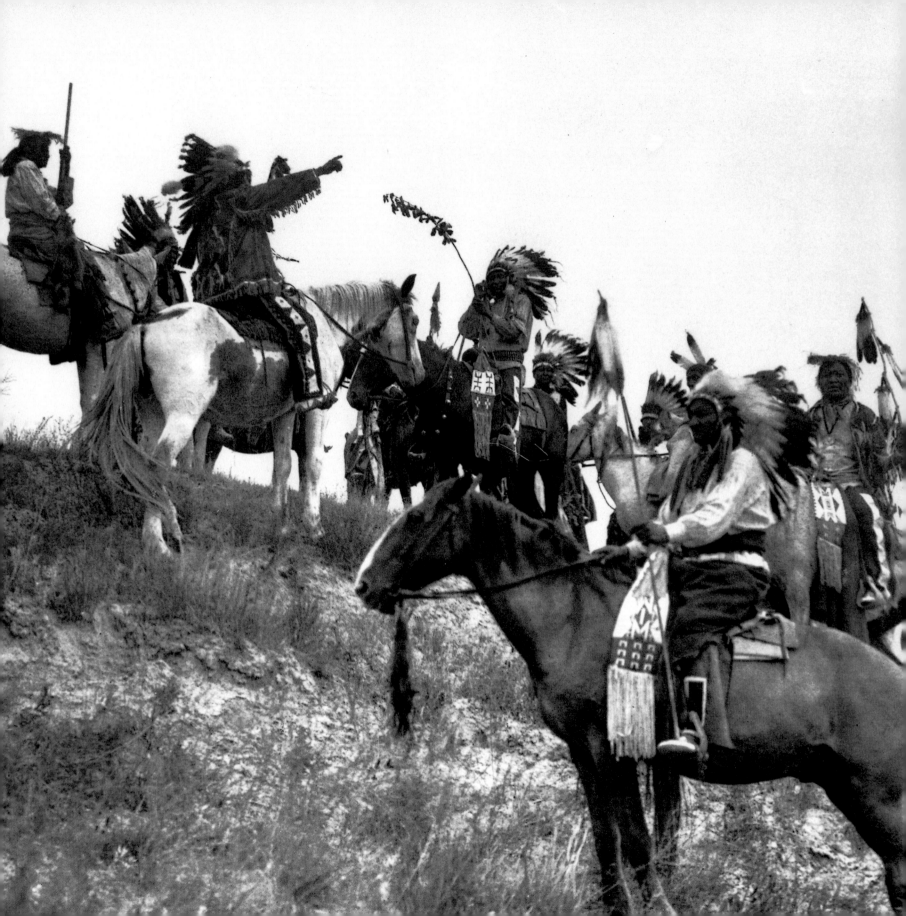

# THE
# WAR TRAIL

wwwwww

*Boys learned at an early age about war by watching the older boys engage in war games with each other. In this way they learned how to defend themselves against an enemy tribe during battle. And also they listened to the older men as they told of their war exploits against the enemy. The warriors said it was braver to touch the enemy with bare hand or coupstick than to kill him. Counting coup on the enemy was a great act of bravery. Screech Owl was of the Blood band who are of the Blackfoot nation from northwestern Montana, southern Alberta, and British Columbia.*

**M**any years ago there lived in the Blood camp a boy named Screech Owl (A´-tsi-tsi). He was rather a lonely boy, and did not care to go with other boys. He liked better to be by himself. Often he would go off alone, and stay out all night away from the camp. He used to pray to all kinds of birds and animals that he saw, and ask them to take pity on him and help him, saying that he wanted to be a warrior. He never used paint. He was a fine looking young man, and he thought it was foolish to use paint to make oneself good looking.

When Screech Owl was about fourteen years old, a large party of Blackfeet were starting to war against the Crees and the Assinaboines. The young man said to his father: "Father, with this war party many of my cousins are going. I think that now I am old enough to go to war, and I would like to join them." His father said, " My son, I am willing you may go." So he joined the party.

*Planning a raid*

His father gave his son his own war horse, a black horse with a white spot on its side — a very fast horse. He offered him arms, but the boy refused them all, except a little trapping axe. He said, "I think this hatchet will be all that I shall need." Just as they were about to start, his father gave the boy his own war headdress. This was not a war bonnet, but a plume made of small feathers, the feathers of thunder birds, for the thunder bird was his father's medicine. He said to the boy, " Now, my son, when you go into battle, put this plume in your head, and wear it as I have worn it."

The party started and travelled north-east, and at length they came to where Fort Pitt now stands, on the Saskatchewan River. When they had got down below Fort Pitt, they saw three riders, going out hunting. These men had not seen the war party. The Blackfeet started around the men, so as to head them off when they should run. When they saw the men, the Screech Owl got off his horse, and took off all his clothes, and put on his father's war plume, and began to ride around, singing his father's war song. The older warriors were getting ready for the attack, and when they saw this young boy acting in this way, they thought he was making fun of the older men, and they said: "Here, look at this boy! Has he no shame? He had better stay behind." When they got on their horses, they told him to stay behind, and they charged the Crees. But the boy, instead of staying behind, charged with them, and took the lead, for he had the best horse of all. He, a boy, was leading the war party, and still singing his war song.

The three Crees began to run, and the boy kept gaining on them. They did not want to separate, they kept together; and as the boy was getting closer and closer, the last one turned in his saddle and shot at the Screech Owl, but missed him. As the Cree fired, the boy whipped up his horse, and rode up beside the Cree and struck him with his little trapping axe, and knocked him off his horse. He paid no attention to the man that he had struck, but rode on to the next Cree. As he came up with him, the Cree raised his gun and fired, but just as he did so, the Blackfoot dropped down on the other side of his horse, and the ball passed over him. He straightened up on his horse, rode up

by the Cree, and as he passed, knocked him off his horse with his axe. When he knocked the second Cree off his horse, the Blackfeet, who were following, whooped in triumph and to encourage him, shouting, "*A-wah-hch*"' (Take courage). The boy was still singing his father's war song.

By this time, the main body of the Blackfeet were catching up with him. He whipped his horse on both sides, and rode on after the third Cree, who was also whipping his horse as hard as he could, and trying to get away. Meantime, some of the Blackfeet had stopped to count *coup* on and scalp the two dead Crees, and to catch the two ponies. Screech Owl at last got near to the third Cree, who kept aiming his gun at him. The boy did not want to get too close, until the Cree had fired his gun, but he was gaining a little, and all the time was throwing himself from side to side on his horse, so as to make it harder for the Cree to hit him. When he had nearly overtaken the enemy, the Cree turned, raised his gun and fired; but the boy had thrown himself down behind his horse, and again the ball passed over him. He raised himself up on his horse, and rushed on the Cree, and struck him in the side of the body with his axe, and then again, and with the second blow, he knocked him off his horse.

The boy rode on a little further, stopped, and jumped off his horse, while the rest of the Blackfeet had come up and were killing the fallen man. He stood off to one side and watched them count *coup* on and scalp the dead.

The Blackfeet were much surprised at what the young man had done. After a little while, the leader decided that they would go back to the camp from which they had come. When he had returned from this war journey this young man's name was changed from A´-tsi-tsi to E-kūs´-kini (Low Horn). This was his first war path.

From that time on the name of E-kūs´-kini was often heard as that of one doing some great deed.

55

From *Blackfoot Lodge Tales: The Story of a Prairie People*, by George Bird Grinnell (Massachusetts 1972). Reprinted by permission of Corner House Publications.

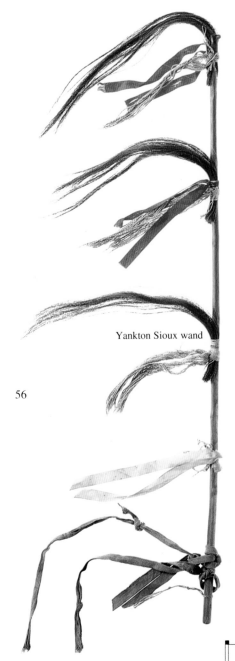

Yankton Sioux wand

56

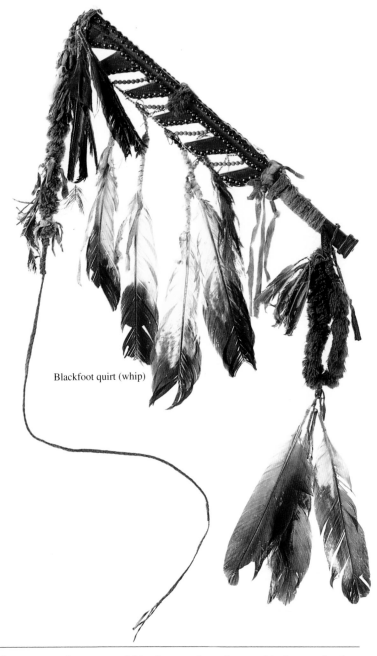

Blackfoot quirt (whip)

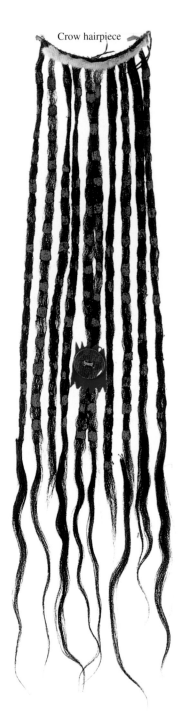

Crow hairpiece

*When two men became good friends, sometimes they would adopt each other as brothers. A Hunka ceremony, Making of Brothers, would be held for them. A staff with horsehair and ribbons was used for the ceremony. The ceremonial quirt* (above), *decorated with tacks, otter fur, ermine, and eagle feathers was owned by the Blackfoot medicine man Weasel Tail. Plains Indians were fond of long hair; those who had short hair wore extensions made from human hair and horsehair.*

Tewa or Zuni shield

*It was said by the elders that in their world everything was in the form of a circle — the earth, sun, moon, the Indians' camps, and even their dwelling places, the tipis. Even the cycle of life, from childhood to childhood, has no beginning or end. The center of the circle is where power dwells.*

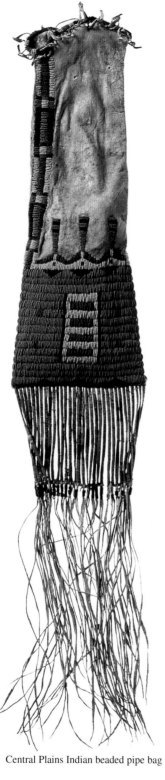

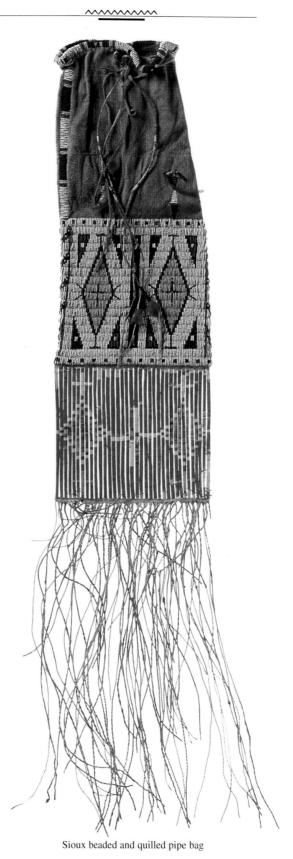

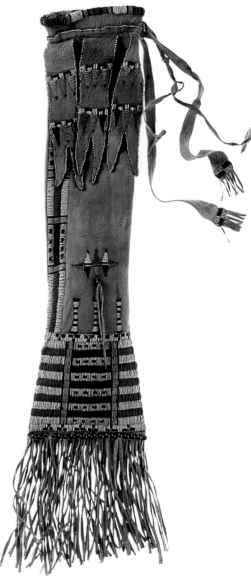

58

Central Plains Indian beaded pipe bag

Sioux beaded and quilled pipe bag

Cheyenne beaded pipe bag

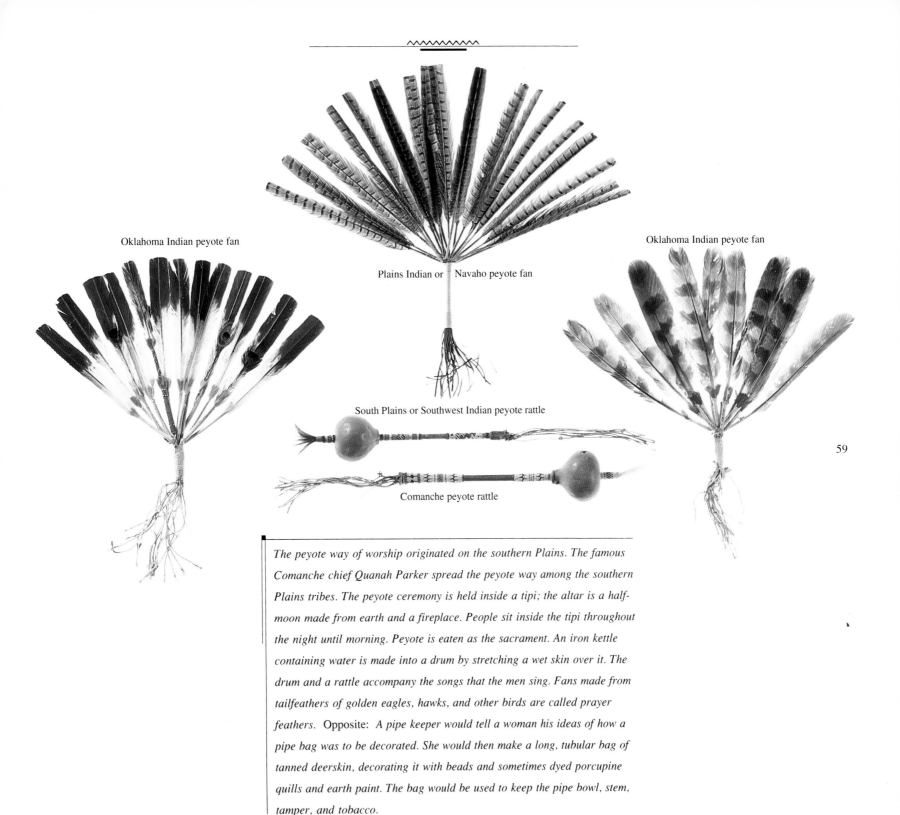

Oklahoma Indian peyote fan

Plains Indian or Navaho peyote fan

Oklahoma Indian peyote fan

South Plains or Southwest Indian peyote rattle

Comanche peyote rattle

*The peyote way of worship originated on the southern Plains. The famous Comanche chief Quanah Parker spread the peyote way among the southern Plains tribes. The peyote ceremony is held inside a tipi; the altar is a half-moon made from earth and a fireplace. People sit inside the tipi throughout the night until morning. Peyote is eaten as the sacrament. An iron kettle containing water is made into a drum by stretching a wet skin over it. The drum and a rattle accompany the songs that the men sing. Fans made from tailfeathers of golden eagles, hawks, and other birds are called prayer feathers. Opposite: A pipe keeper would tell a woman his ideas of how a pipe bag was to be decorated. She would then make a long, tubular bag of tanned deerskin, decorating it with beads and sometimes dyed porcupine quills and earth paint. The bag would be used to keep the pipe bowl, stem, tamper, and tobacco.*

*The drum is considered a sacred object. It is made from bison or elk rawhide that has been wetted, stretched over a round frame, and laced with a strip of rawhide. Once an Old Man said, "Have respect for the drum and the men seated around the drum. This drum knows your thoughts and feelings; it can make you dance, make you feel good, and make you cry. The drum is the heartbeat of our people. Take care of the drum; it symbolizes unity." Drums are used in religious and social gatherings. Small hand drums are used in the round dance — a social dance — and to accompany stickgame, a gambling game popular with most Plains, Columbia Plateau, and Great Basin tribes.*

Cheyenne rim drum

Middle Woodlands
Indian drumstick

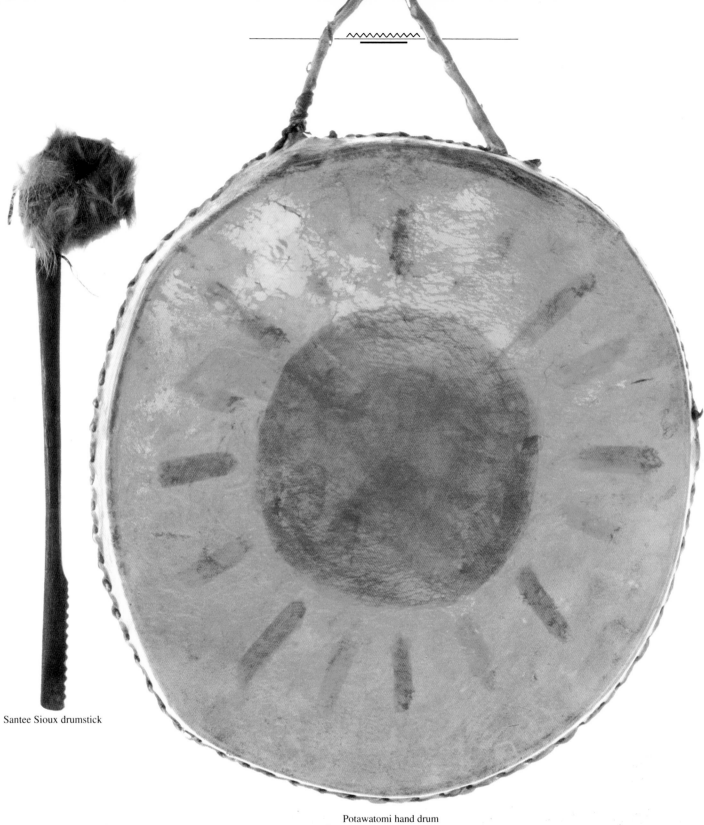

61

Santee Sioux drumstick

Potawatomi hand drum

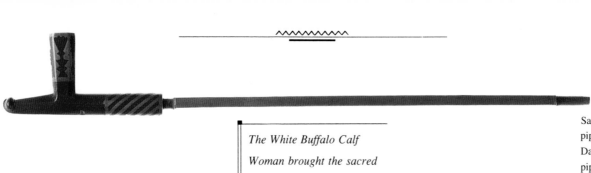

Sauk and Fox
pipe bowl with
Dakota Sioux
pipe stem

*The White Buffalo Calf Woman brought the sacred pipe to the Sioux tribe. The pipe is not just an object, but is considered sacred among the Plains Indian tribes. The pipes were kept in pipe bags*

Brule Sioux
pipe bowl
and stem

*(opposite) that were beautifully decorated with beads and porcupine quills. After the bowl and stem were connected, the pipe was filled with tobacco — usually the inner bark of the*

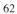

62

Sioux pipe
bowl and stem

*red willow. Prayers and good thoughts were sent through smoke from the pipe. Once an Old Man said, "We Indian people were put upon this earth with tobacco."*

Potawatomi
pipe bowl
and stem

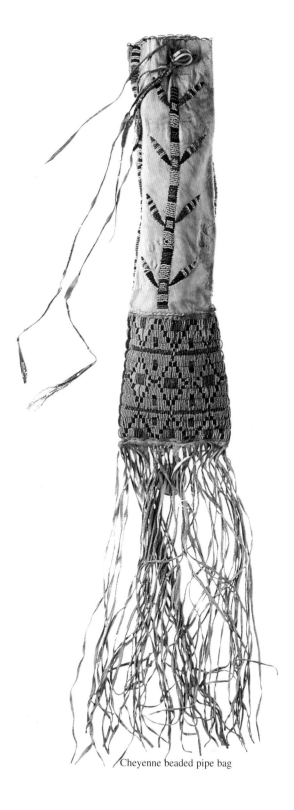

Cheyenne beaded pipe bag

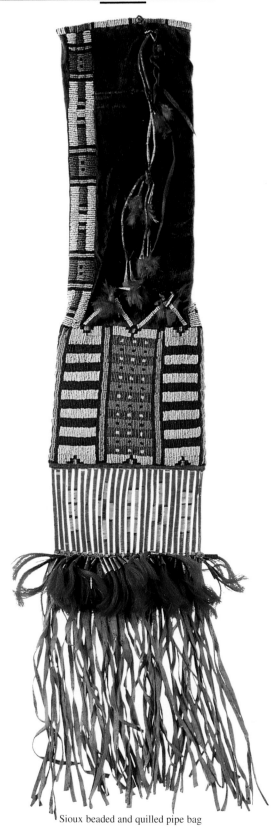

Sioux beaded and quilled pipe bag

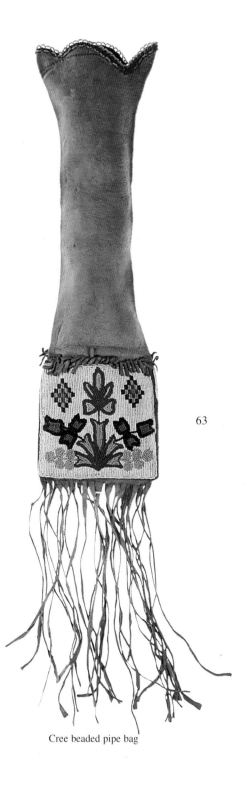

Cree beaded pipe bag

63

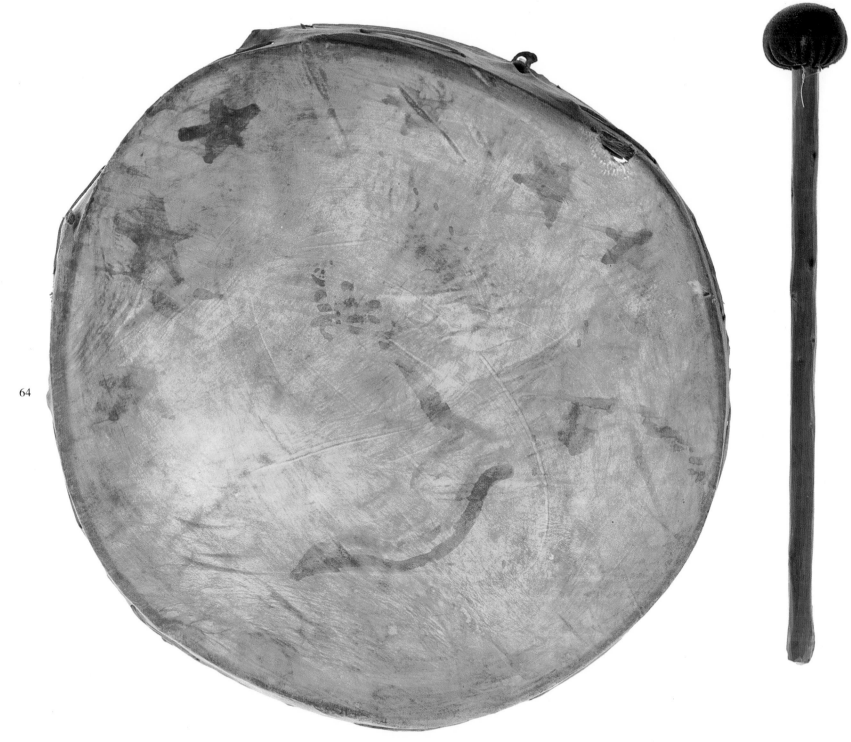

64

Plains Indian rawhide drum and stick

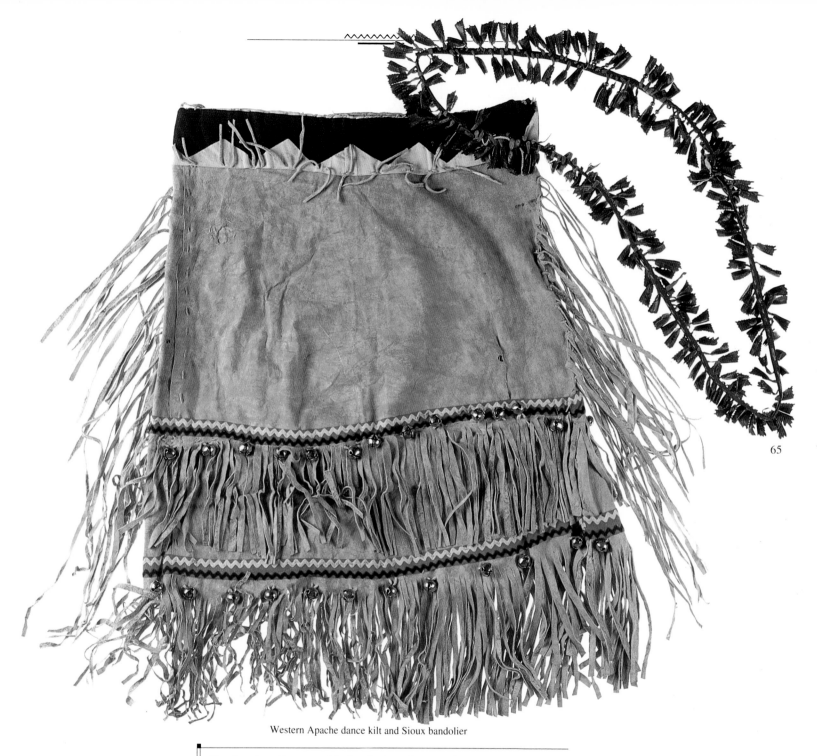

Western Apache dance kilt and Sioux bandolier

*The Apache tribe roamed in bands throughout southwestern Arizona, New Mexico, and Texas. The Jicarilla Apaches' lifestyle was strongly influenced by contact with the Utes and other Plains Indian tribes. The Jicarilla Apaches live in northern New Mexico. This drum and kilt were used by dancers in their ceremonial Devil Dance.*

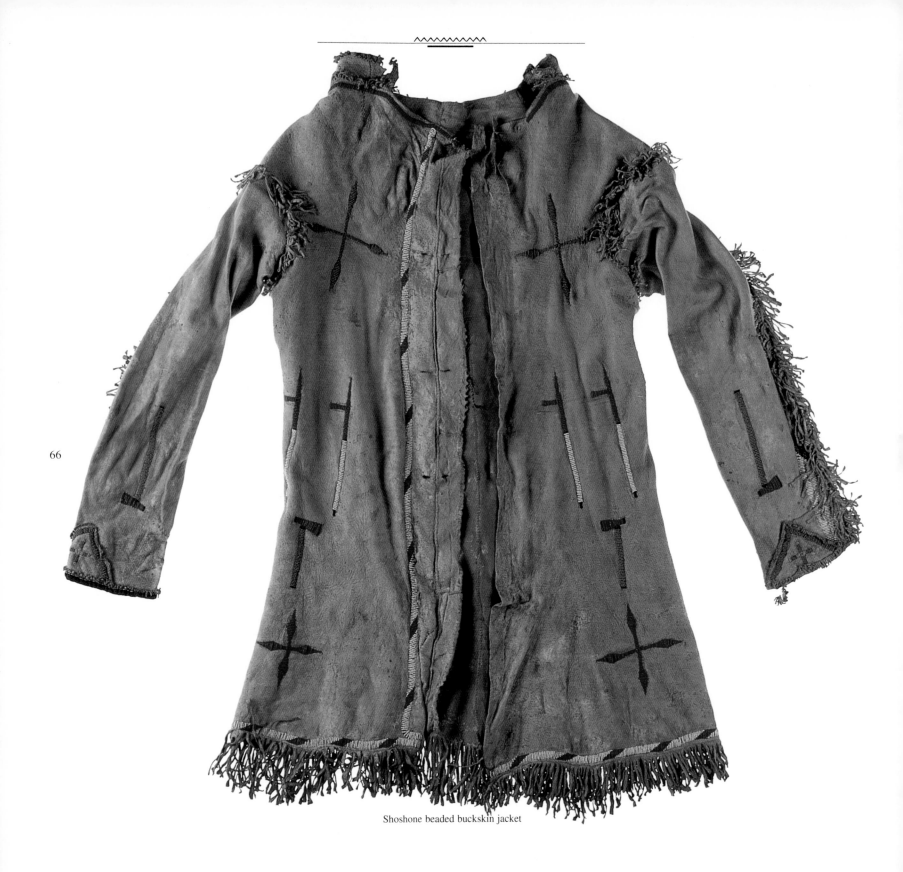

66

Shoshone beaded buckskin jacket

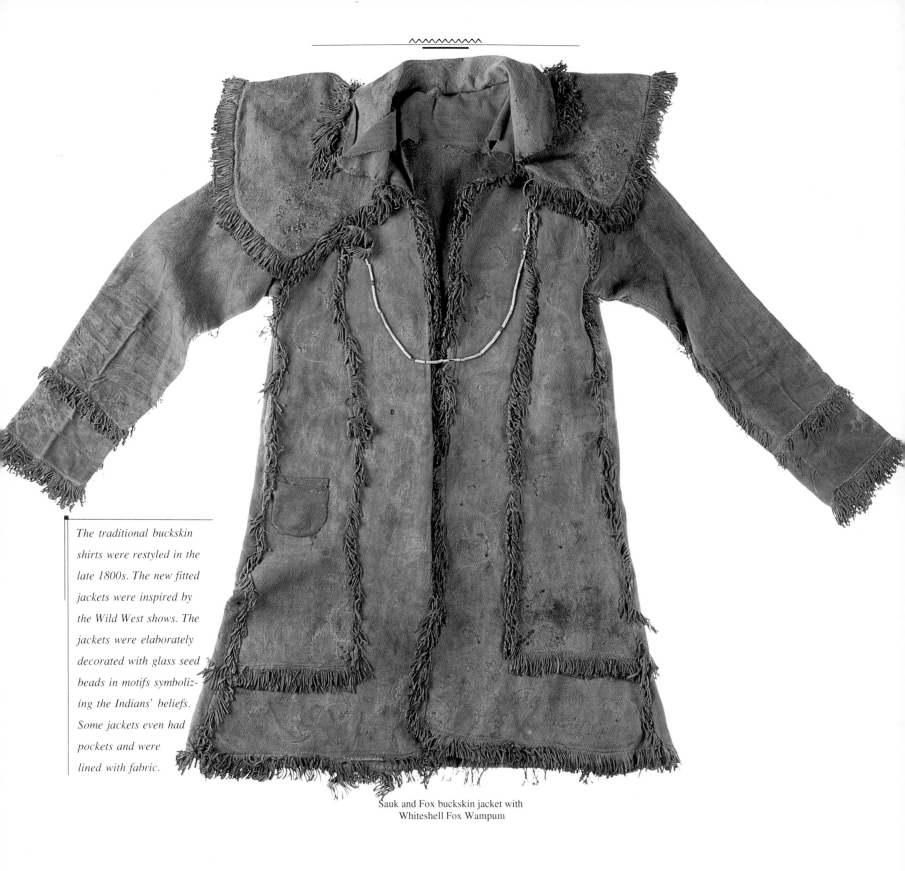

The traditional buckskin shirts were restyled in the late 1800s. The new fitted jackets were inspired by the Wild West shows. The jackets were elaborately decorated with glass seed beads in motifs symbolizing the Indians' beliefs. Some jackets even had pockets and were lined with fabric.

Sauk and Fox buckskin jacket with
Whiteshell Fox Wampum

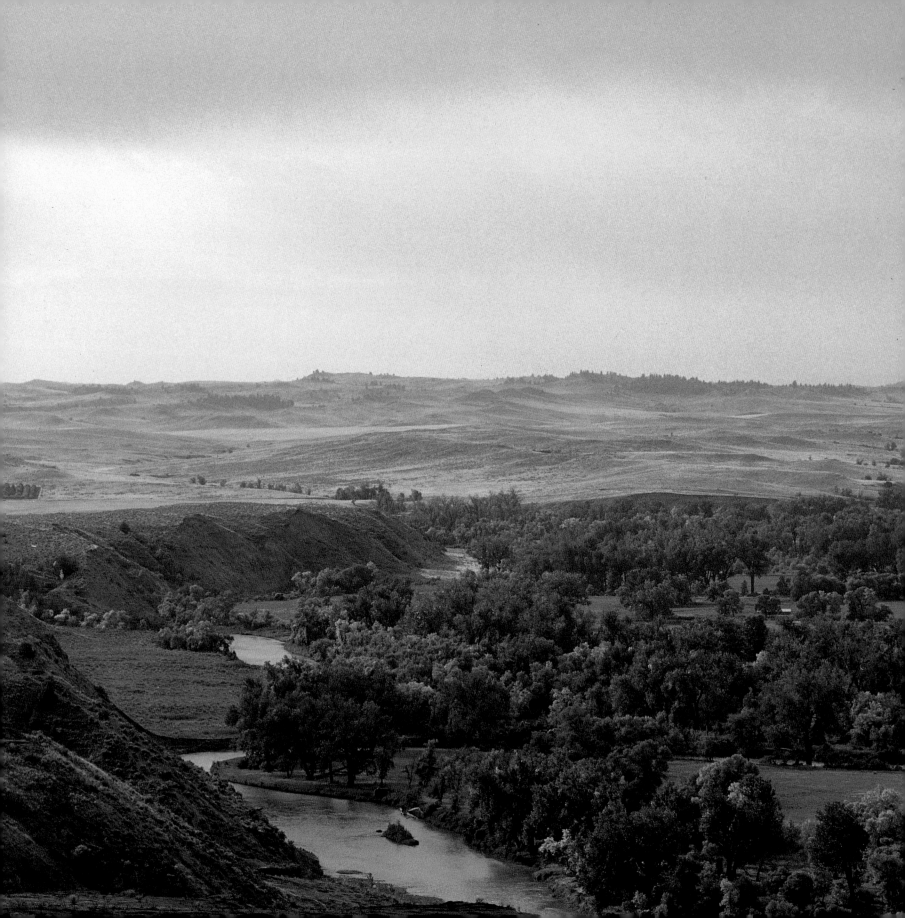

# THE
# RUBBING
# OUT OF
# LONG HAIR

*The Greasy Grass (Little Big Horn)*
*River in southeastern Montana.*

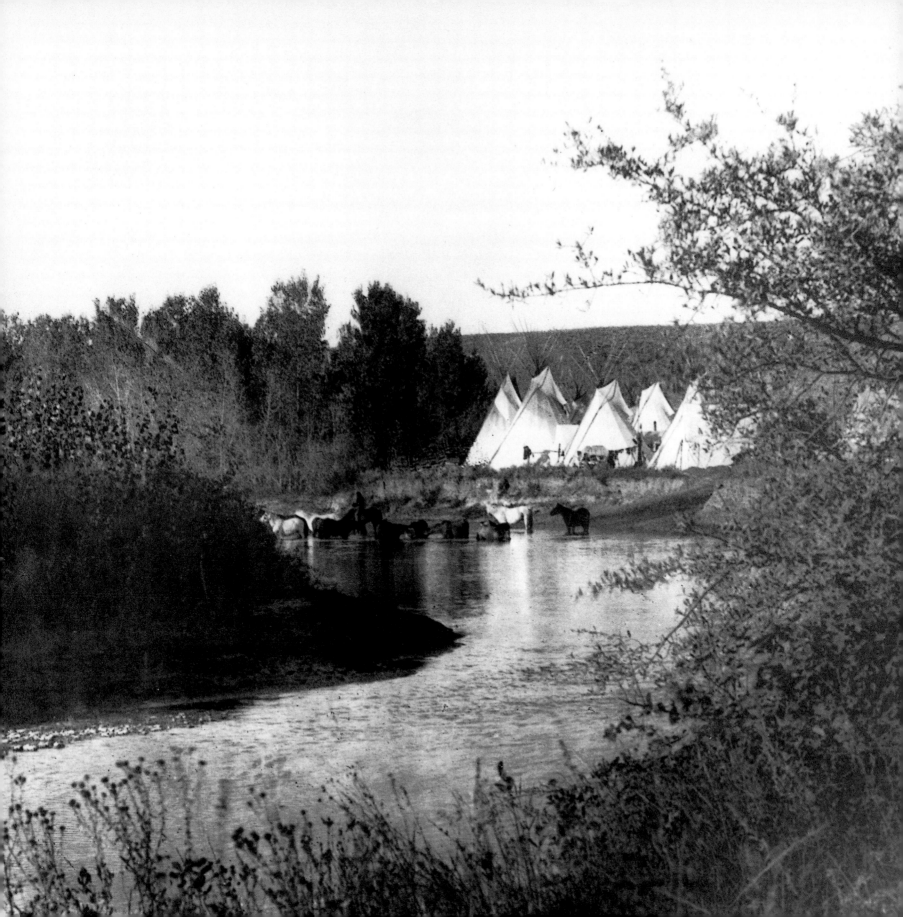

# THE RUBBING OUT OF LONG HAIR

*Only the mountains and hills live forever, and any day is a good day to die. On battle days, some warriors do not ride the trail back to camp. Instead, they travel over a different road, the spirit trail to the happy hunting grounds, beyond the ridge. It is better to die in war and to be remembered for your brave deeds than to die of old age. Iron Hawk was a Sioux of the Hunkpapa band. He was fourteen years old when he fought in the Battle of the Little Big Horn in Montana. In this battle General Custer (Long Hair) met his death. The battle was known by the Sioux nation as the Fight on the Greasy Grass River. The fight began with a surprise charge by the soldiers.*

I am a Hunkpapa, and, as I told you before, I was fourteen years old. The sun was overhead and more, but I was eating my first meal that day, because I had been sleeping. While I was eating I heard the crier saying: "The chargers are coming." I jumped up and rushed out to our horses. They were grazing close to camp. I roped one, and the others stampeded, but my older brother had caught his horse already and headed the others off. When I got on my horse with the rope hitched around his nose, the soldiers were shooting up there and people were running and men and boys were catching their horses that were scared because of the shooting and yelling. I saw little children running up from the river where they had been swimming; and all the women and children were running down the valley.

Our horses stampeded down toward the Minneconjous, but we rounded them up again and brought them back. By now warriors were running toward the soldiers, and getting on the ponies, and many of the Hunkpapas were

*Crow camp along the Greasy Grass (Little Big Horn) River in southeastern Montana.*

gathering in the brush and timber near the place where the soldiers had stopped and got off their horses. I rode past a very old man who was shouting: "Boys, take courage! Would you see these children taken away from me like dogs?"

I went into our tepee and got dressed for war as fast as I could; but I could hear bullets whizzing outside, and I was so shaky that it took me a long time to braid an eagle feather into my hair. Also, I had to hold my pony's rope all the time, and he kept jerking me and trying to get away. While I was doing this, crowds of warriors on horses were roaring by up stream, yelling: "Hoka hey!" Then I rubbed red paint all over my face and took my bow and arrows and got on my horse. I did not have a gun, only a bow and arrows.

When I was on my horse, the fight up stream seemed to be over, because everybody was starting back downstream and yelling: "It's a good day to die!" Soldiers were coming to the other end of the village, and nobody knew how many there were down there.

72

A man by the name of Little Bear rode up to me on a pinto horse, and he had a very pretty saddle blanket. He said: "Take courage, boy! The earth is all that lasts!" So I rode fast with him and the others downstream, and many of us Hunkpapas gathered on the east side of the river at the foot of a gulch that led back up the hill where the second soldier band[1] was. There was a very brave Shyela with us, and I heard someone say: "He is going!" I looked, and it was this Shyela. He had on a spotted war bonnet and a spotted robe made of some animal's skin and this was fastened with a spotted belt. He was going up the hill alone and we all followed part way. There were soldiers along the ridge up there and they were on foot holding their horses. The Shyela rode right close to them in a circle several times and all the soldiers shot at him. Then he rode back to where we had stopped at the head of the gulch. He was saying "Ah, ah!"

Someone said: "Shyela friend, what is the matter?" He began undoing his spotted belt, and when he shook it, bullets dropped out. He was very sacred and the soldiers could not hurt him. He was a fine looking man.

[1]Custer's.

We stayed there awhile waiting for something and there was shooting everywhere. Then I heard a voice crying: "Now they are going, they are going!" We looked up and saw the cavalry horses stampeding. These were all gray horses.

I saw Little Bear's horse rear and race up hill toward the soldiers. When he got close, his horse was shot out from under him, and he got up limping because the bullet went through his leg; and he started hobbling back to us with the soldiers shooting at him. His brother-friend, Elk Nation, went up there on his horse and took Little Bear behind him and rode back safe with bullets striking all around him. It was his duty to go to his brother-friend even if he knew he would be killed.

By now a big cry was going up around the soldiers up there and the warriors were coming from everywhere and it was getting dark with dust and smoke.

We saw soldiers start running down hill right towards us. Nearly all of them were afoot, and I think they were so scared that they didn't know what they were doing. They were making their arms go as though they were running very fast, but they were only walking. Some of them shot their guns in the air. We all yelled "Hoka hey!" and charged toward them, riding all around them in the twilight that had fallen on us.

I met a soldier on horseback, and I let him have it. The arrow went through from side to side under his ribs and it stuck out on both sides. He screamed and took hold of his saddle horn and hung on, wobbling, with his head hanging down. I kept along beside him, and I took my heavy bow and struck him across the back of the neck. He fell from his saddle, and I got off and beat him to death with my bow. I kept on beating him awhile after he was dead, and every time I hit him I said "Hownh!" I was mad, because I was thinking of the women and little children running down there, all scared and out of breath. These Wasichus wanted it, and they came to get it, and we gave it to them. I did not see much more. I saw Brings Plenty kill a soldier with a war club. I saw Red Horn Buffalo fall. There was a Lakota riding along the

edge of the gulch, and he was yelling to look out, that there was a soldier hiding in there. I saw him charge in and kill the soldier and begin slashing him with a knife.

Then we began to go towards the river, and the dust was lifting so that we could see the women and children coming over to us from across the river. The soldiers were all rubbed out there and scattered around.

The women swarmed up the hill and began stripping the soldiers. They were yelling and laughing and singing now. I saw something funny. Two fat old women were stripping a soldier, who was wounded and playing dead. When they had him naked, they began to cut something off that he had, and he jumped up and began fighting with the two fat women. He was swinging one of them around, while the other was trying to stab him with her knife. After awhile, another woman rushed up and shoved her knife into him and he died really dead. It was funny to see the naked Wasichu fighting with the fat women.

By now we saw that our warriors were all charging on some soldiers that had come from the hill up river to help the second band that we had rubbed out. They ran back and we followed, chasing them up on their hill again where they had their pack mules. We could not hurt them much there, because they had been digging to hide themselves and they were lying behind saddles and other things. I was down by the river and I saw some soldiers come down there with buckets. They had no guns, just buckets. Some boys were down there, and they came out of the brush and threw mud and rocks in the soldiers' faces and chased them into the river. I guess they got enough to drink, for they are drinking yet. We killed them in the water.

Afterwhile it was nearly sundown, and I went home with many others to eat, while some others stayed to watch the soldiers on the hill. I hadn't eaten all day, because the trouble started just when I was beginning to eat my meal.

74

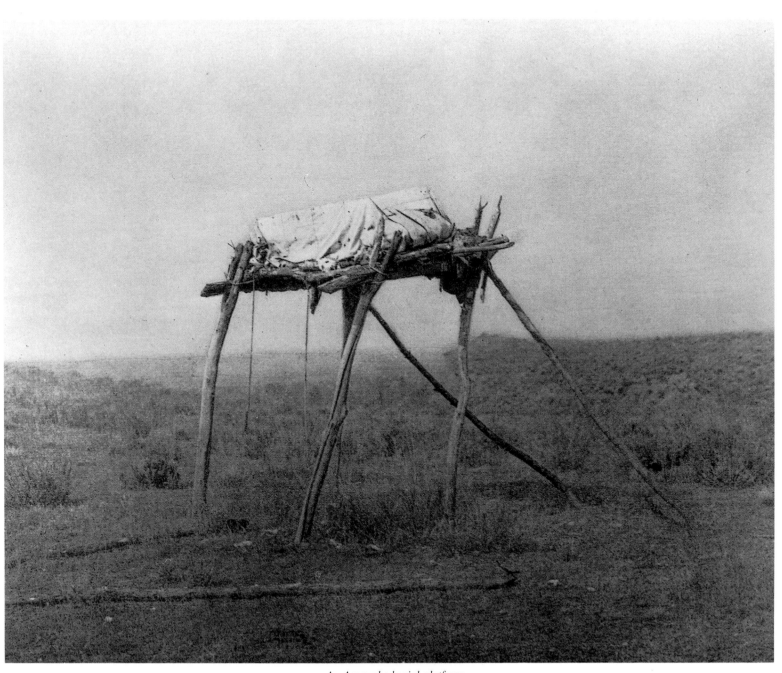

*An Apsaroke burial platform.*

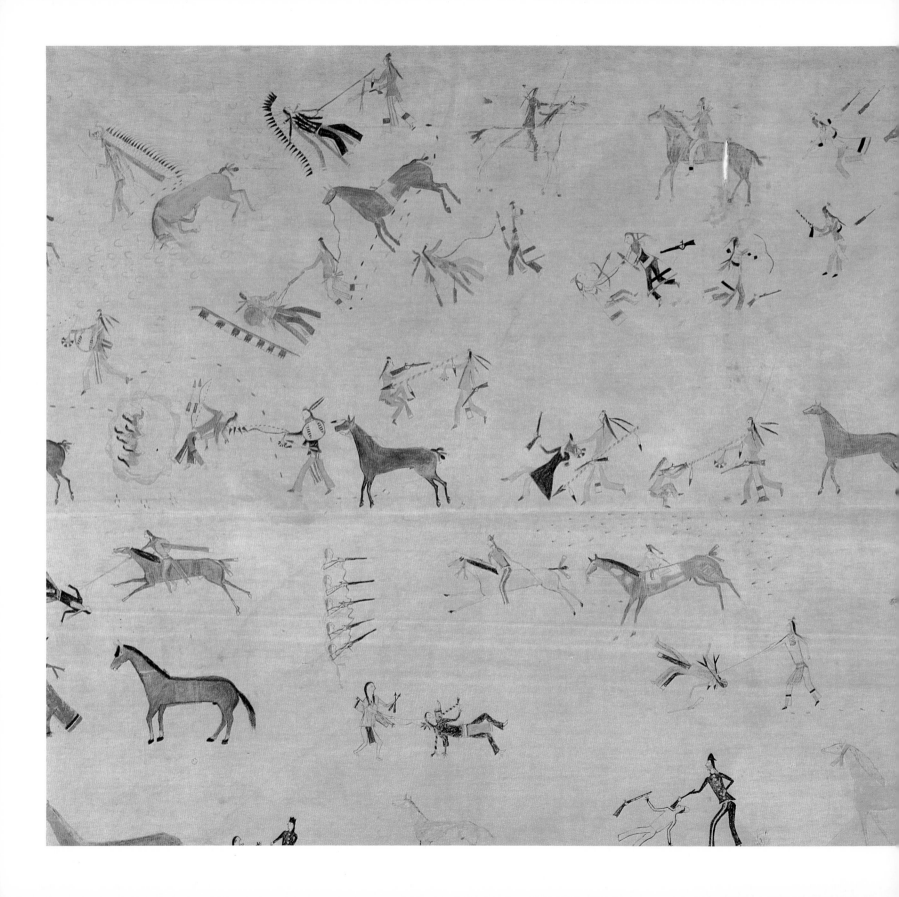

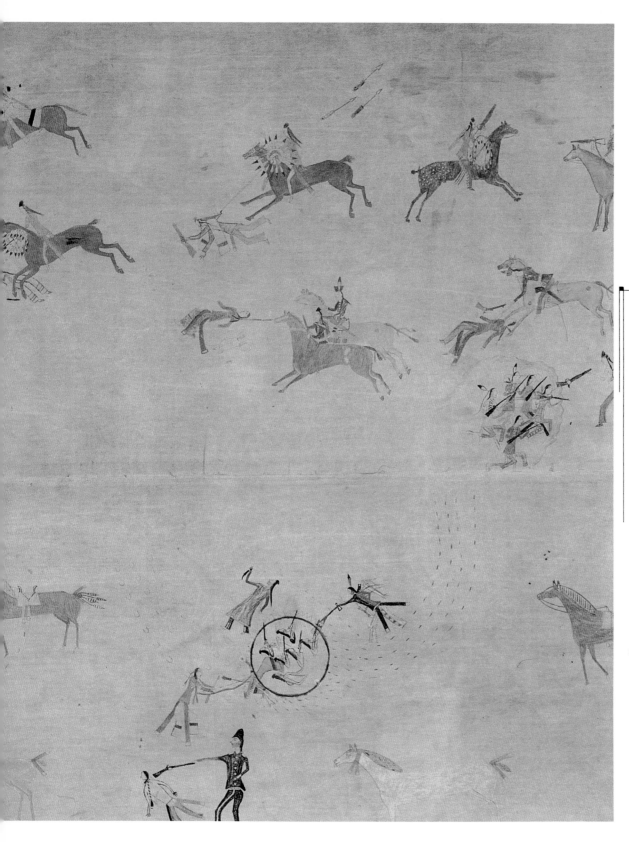

According to Shoshone custom, it was a man's duty to paint his exploits in battle on the family tipi liner. This painting depicts a battle against the Crow tribe. The place of the battle is now called Crow Heart Butte because the fierce Shoshone chief took out the heart of a Crow warrior with his bare hands and displayed it to his warriors. The chief carried his men to victory; not one Crow warrior was left alive.

77

Shoshone tipi liner

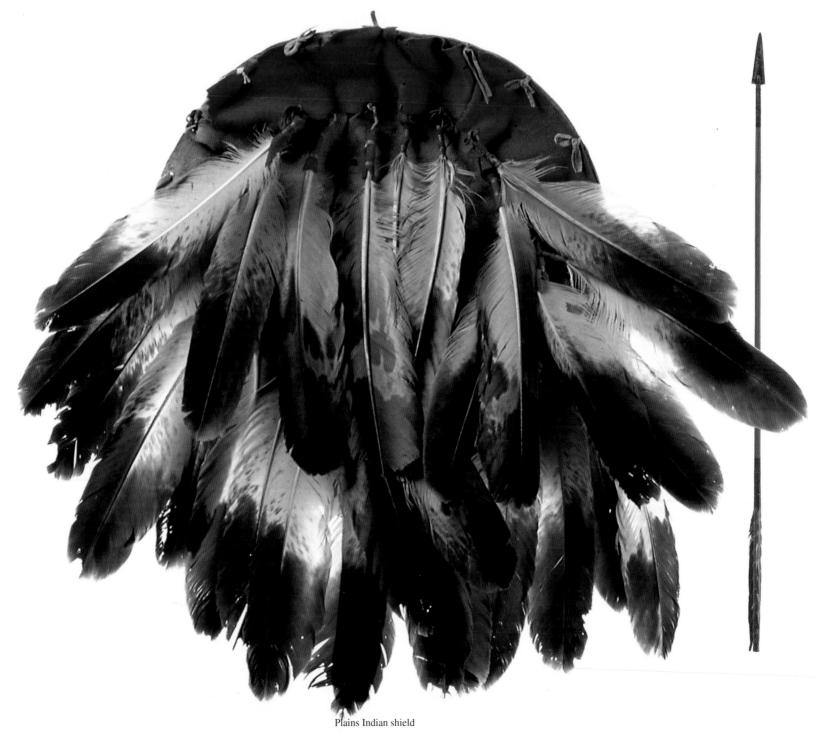

Plains Indian shield

When all living things were birds and animals, there was an Old Man in the tribe who had the power to heal the sick, and who could see into the future. This Old Man prayed to the Creator so that his people could live in harmony with each other and with all life forces and the universe. This Old Man became the golden eagle, a messenger for his people to the Creator. His talons were strung together and worn by a medicine man; his wing bones were made into whistles; and his feathers and plumes were used in religious ceremonies and worn in remembrance of the Great Spirit.

Sioux arrows

Cheyenne warbonnet

79

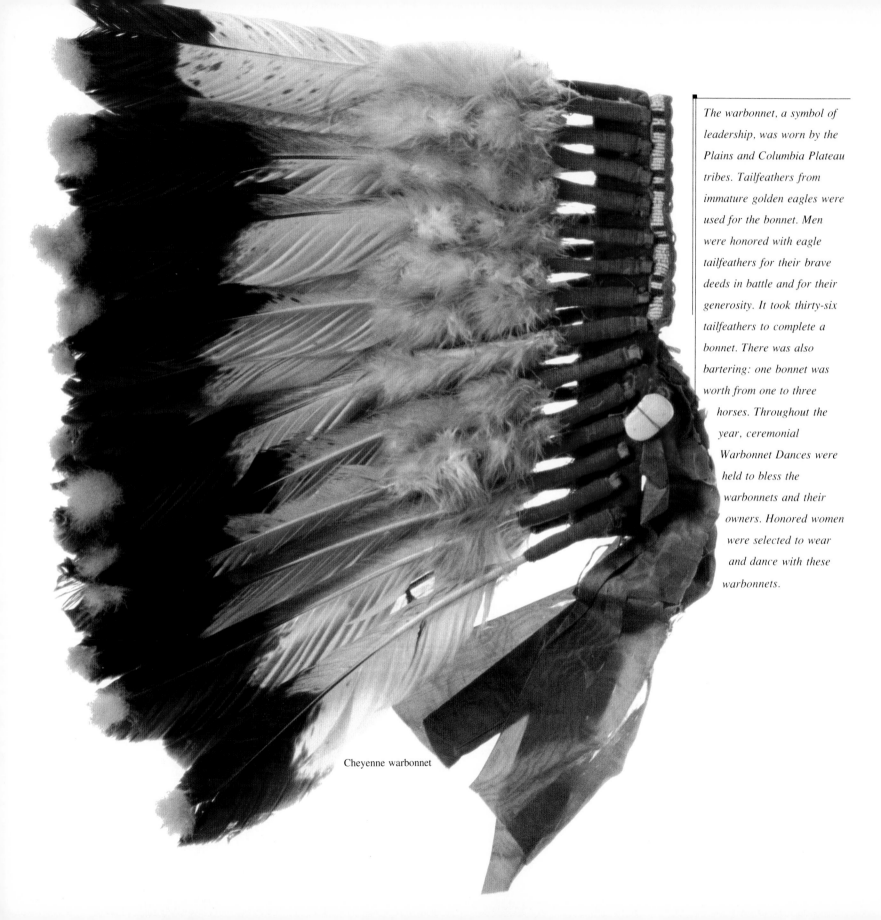

*The warbonnet, a symbol of leadership, was worn by the Plains and Columbia Plateau tribes. Tailfeathers from immature golden eagles were used for the bonnet. Men were honored with eagle tailfeathers for their brave deeds in battle and for their generosity. It took thirty-six tailfeathers to complete a bonnet. There was also bartering: one bonnet was worth from one to three horses. Throughout the year, ceremonial Warbonnet Dances were held to bless the warbonnets and their owners. Honored women were selected to wear and dance with these warbonnets.*

Cheyenne warbonnet

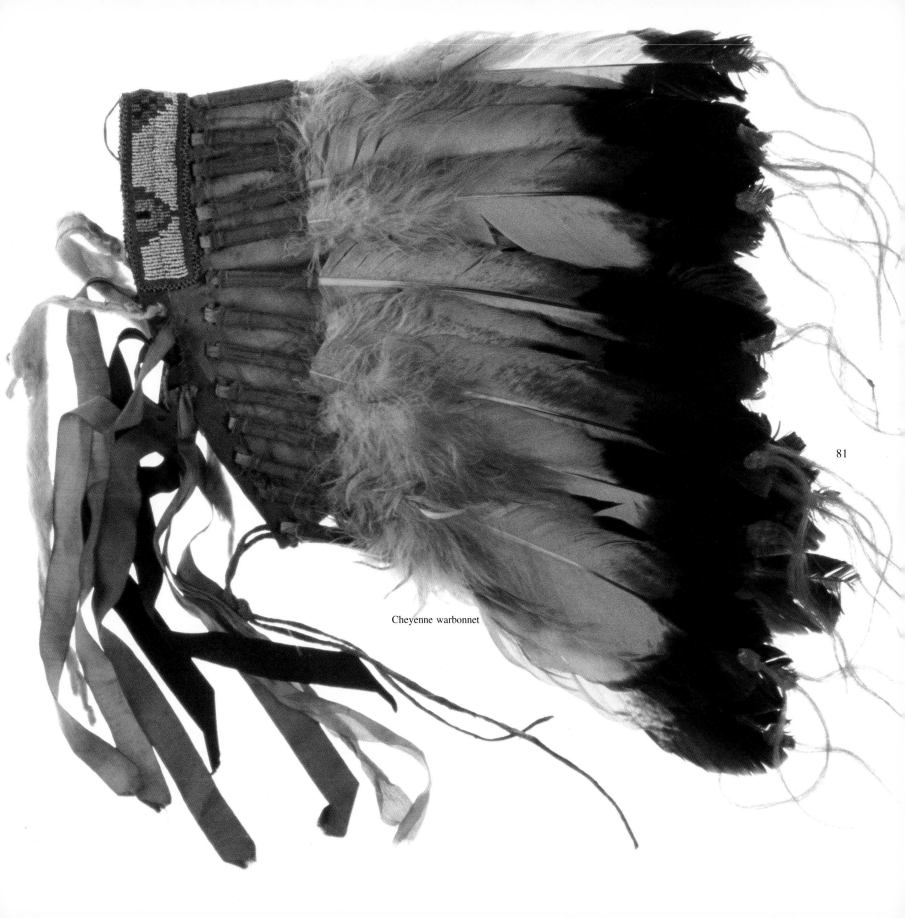

Cheyenne warbonnet

81

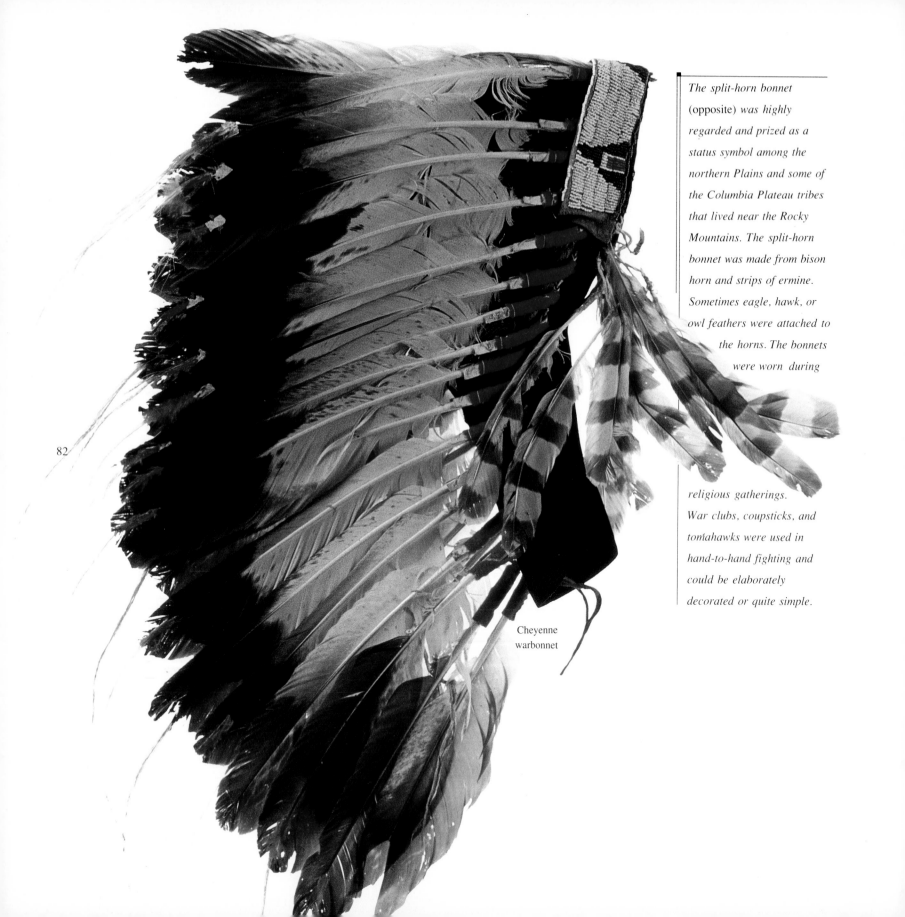

*The split-horn bonnet (opposite) was highly regarded and prized as a status symbol among the northern Plains and some of the Columbia Plateau tribes that lived near the Rocky Mountains. The split-horn bonnet was made from bison horn and strips of ermine. Sometimes eagle, hawk, or owl feathers were attached to the horns. The bonnets were worn during religious gatherings. War clubs, coupsticks, and tomahawks were used in hand-to-hand fighting and could be elaborately decorated or quite simple.*

82

Cheyenne
warbonnet

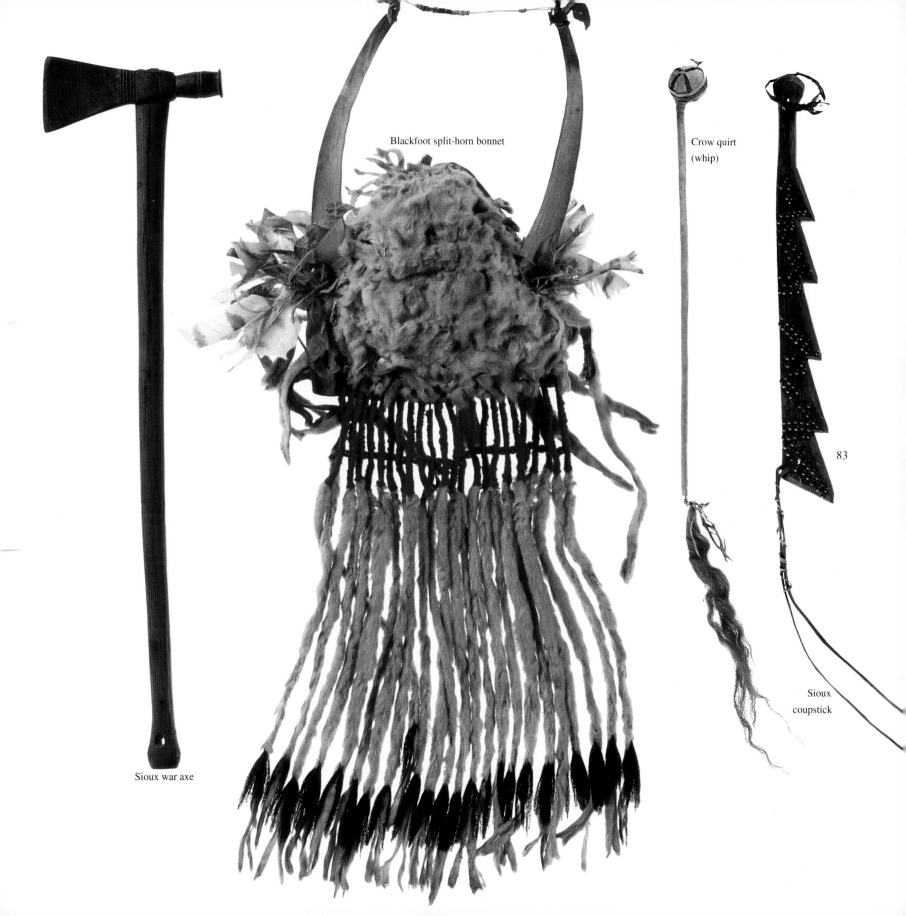

Sioux war axe

Blackfoot split-horn bonnet

Crow quirt
(whip)

83

Sioux
coupstick

Chippewa drum and stick

84

Plains Indian antler quirt (whip)

Blackfoot club (coupstick)

Sioux breastplate

*Long, tubular pieces called hairpipes were first brought to the Plains Indian tribes as a trade item in the 1850s. The hairpipes were made into breastplates and worn as decoration* (above right). *A headdress made of guard hair from the porcupine, based with dyed red deer tail is called a roach* (opposite). *This particular type of headdress was common throughout the Woodland, Plains, and Columbia Plateau tribes. During the reservation days the roach became part of a man's dance outfit for a social dance called grass dance.*

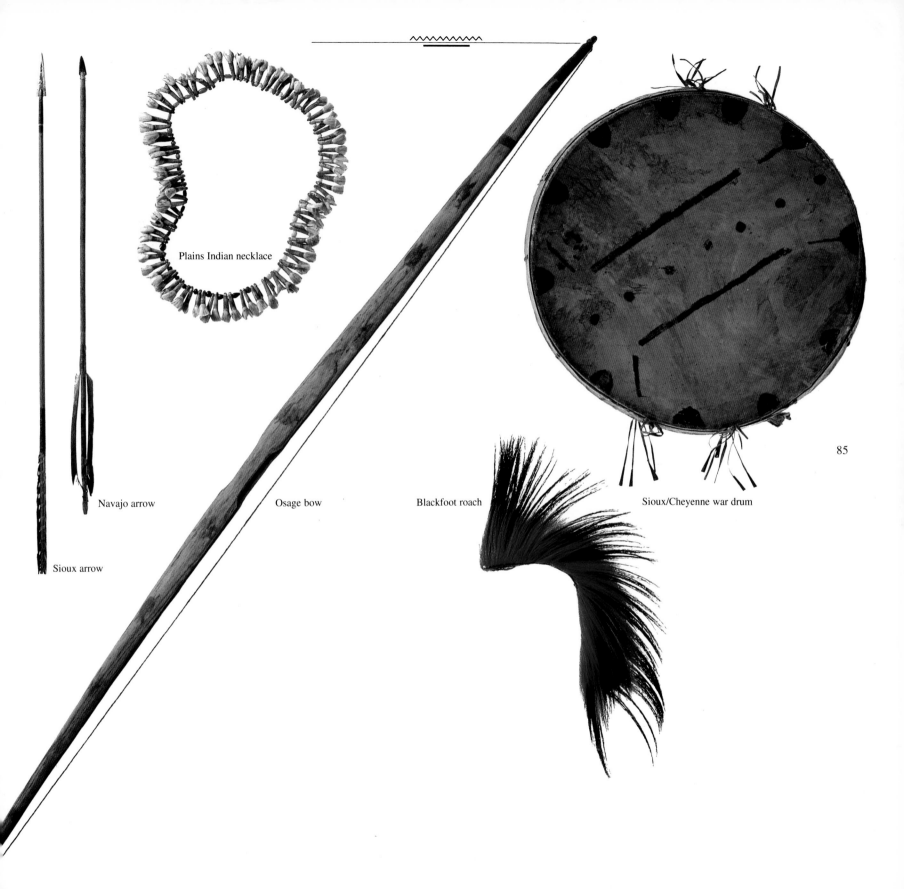

Plains Indian necklace

Navajo arrow

Sioux arrow

Osage bow

Blackfoot roach

Sioux/Cheyenne war drum

85

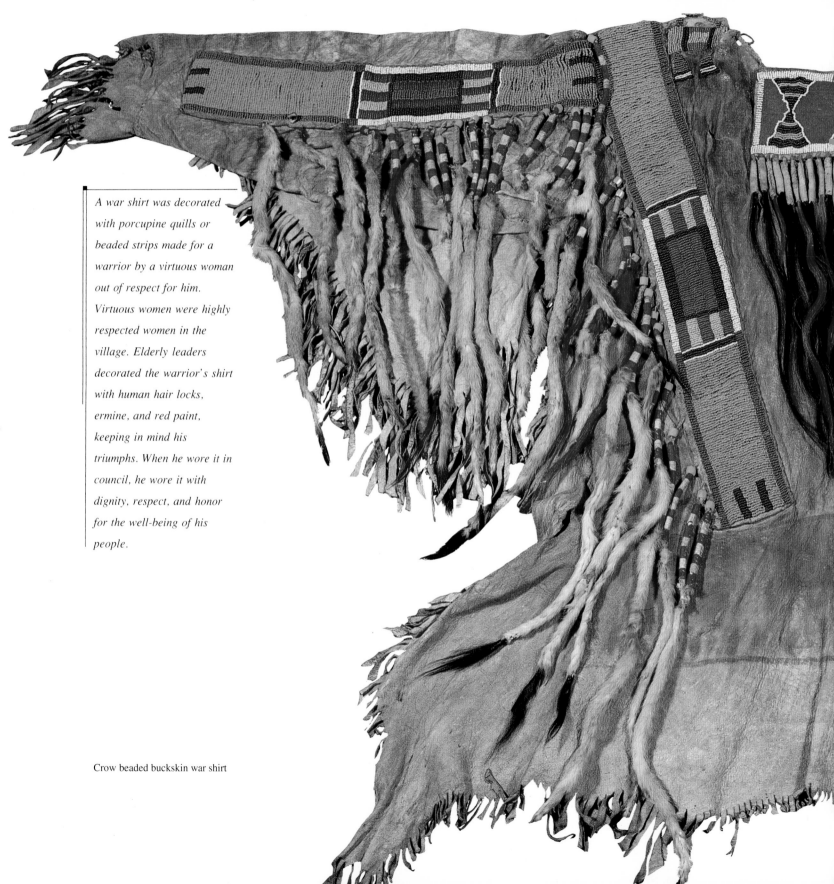

A war shirt was decorated with porcupine quills or beaded strips made for a warrior by a virtuous woman out of respect for him. Virtuous women were highly respected women in the village. Elderly leaders decorated the warrior's shirt with human hair locks, ermine, and red paint, keeping in mind his triumphs. When he wore it in council, he wore it with dignity, respect, and honor for the well-being of his people.

Crow beaded buckskin war shirt

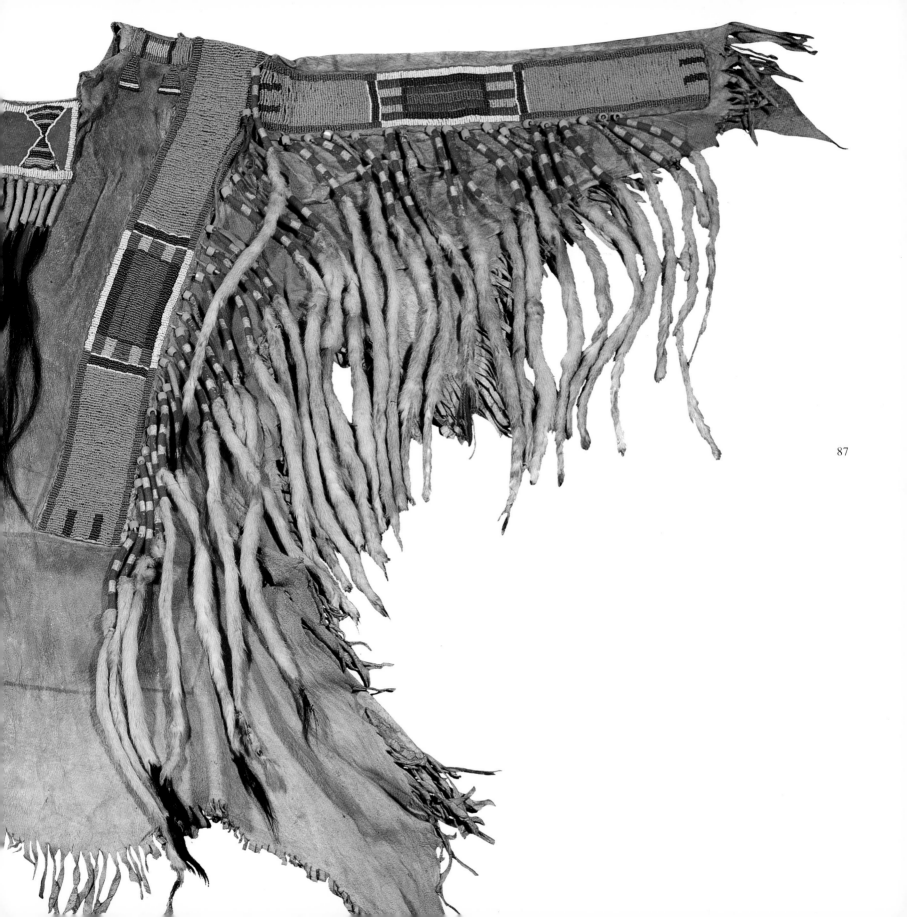

87

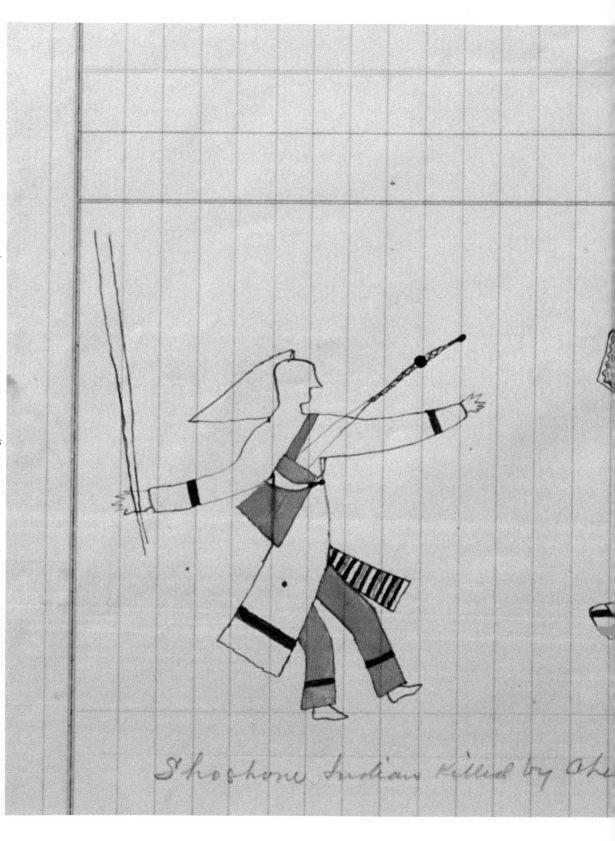

*After the Cheyenne were settled on the reservation they would go to the army fort to pick up their rations from the soldiers. Some of the men would ask the agent who was over their people to give them pencils and paper with lines, which they called ledgerbook. Like the white man writing in his journal, the Indians recorded their past, drawing the accounts of battles they fought against enemy tribes and the soldiers.*

88

Cheyenne ledger drawing

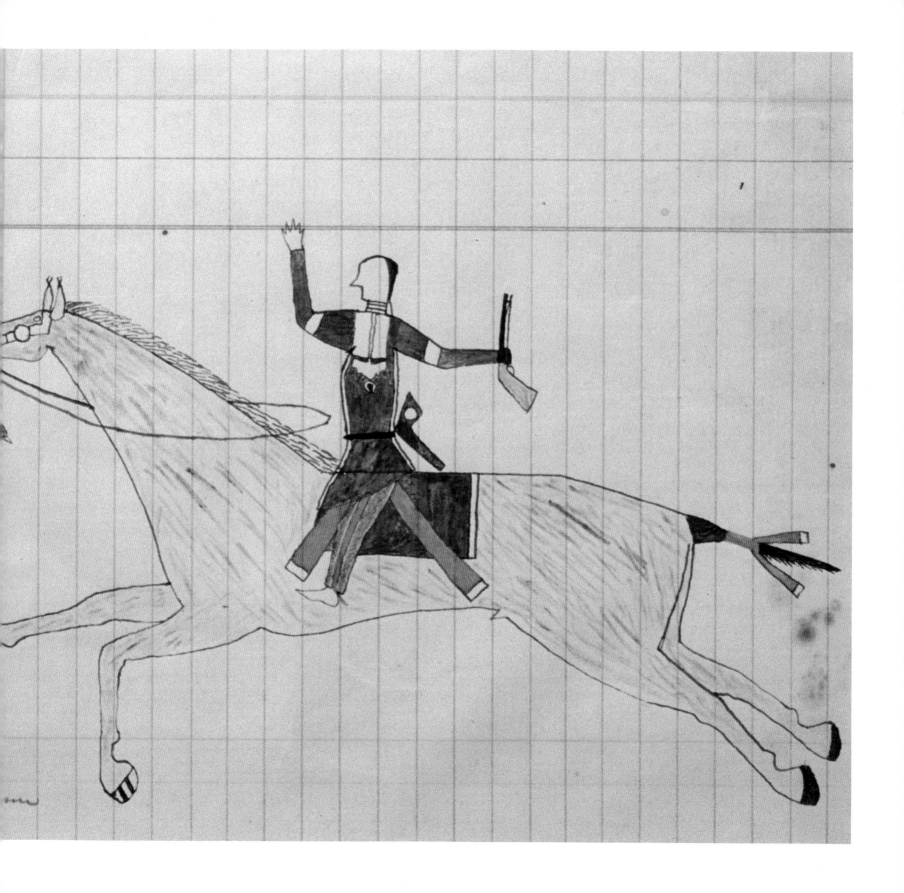

Winnebago war
club with Crow
scalp lock and
beads

Prairie Sioux quirt (whip)

Blackfoot quirt (whip)

90

Quirts were riding whips
made from elk antler,
bison bone, and wood.
They might be carved and
decorated with brass
tacks and have a long,
narrow, rawhide strip
attached to one end, and
a beaded wrist strap
attached to the other end.
Gunstock clubs, com-
monly used by the
Woodland and northern
Plains Indians, were
often decorated with
brass tacks like the one
shown above the quirts.
This Sioux quiver
and bow case is made
from tanned skin. A
willow stick is inserted
along the inside seam,
and denim fabric is
sewn around the top.

Sioux bow and arrow quiver

Plains Indian arrows

Crow shield
and scalp

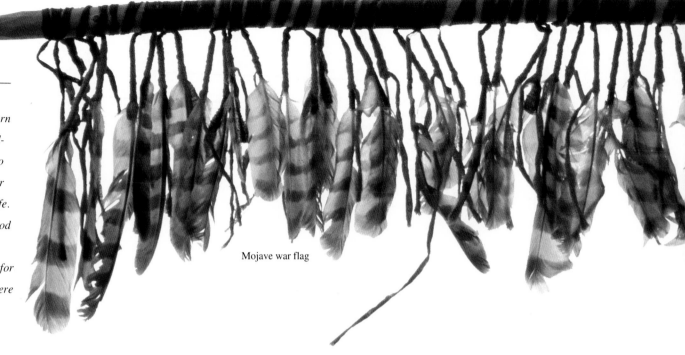

Mojave war flag

*Sioux legend tells us that when a male child was born into the world, a bow-and-arrow bundle was given to him by the Great Spirit for survival throughout his life. Bows were made from wood and from elk and bighorn sheep antlers, with sinew for the bowstrings. Arrows were*

92

Sioux bow

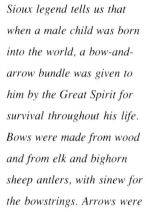

Yahi arrow

Diegueño arrow

Sioux arrow

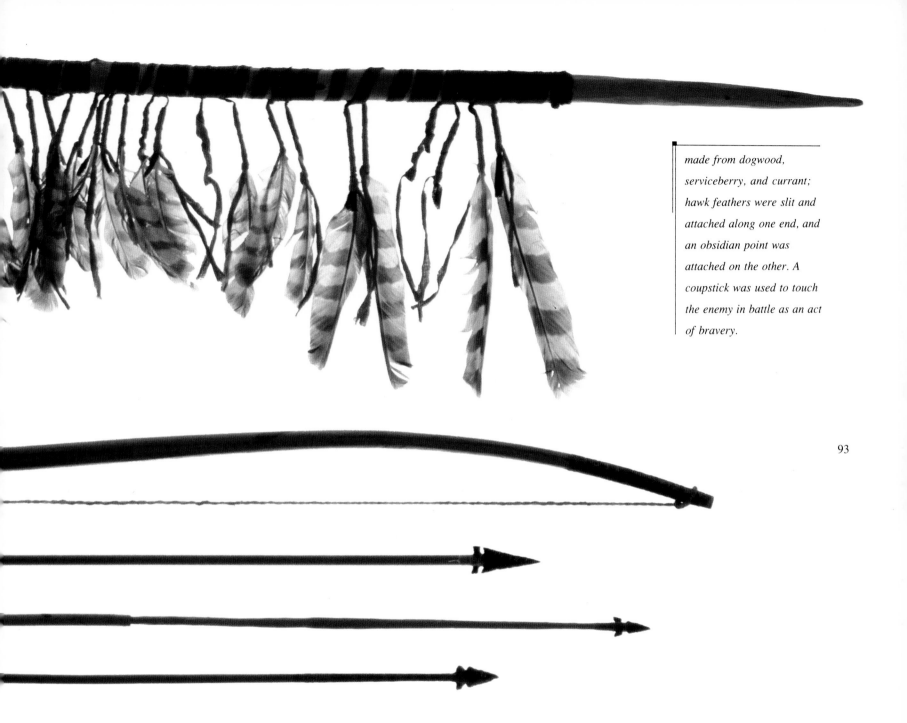

made from dogwood, serviceberry, and currant; hawk feathers were slit and attached along one end, and an obsidian point was attached on the other. A coupstick was used to touch the enemy in battle as an act of bravery.

93

94

Sioux
knife sheath

Sioux knife sheath

Flathead knife sheath

Plains Ojibwa knife

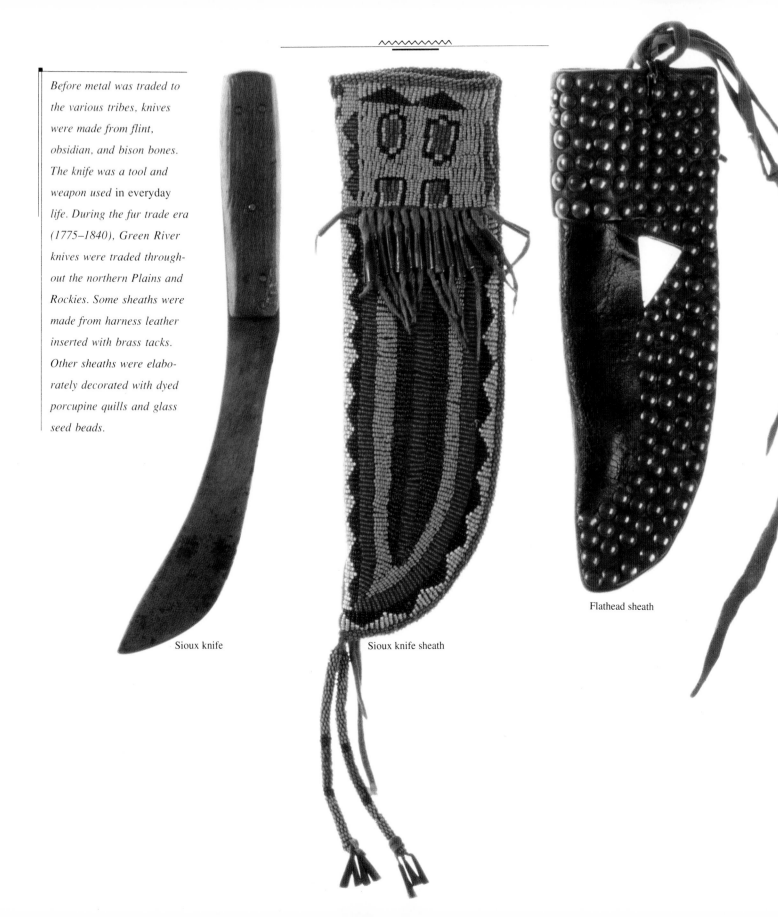

*Before metal was traded to the various tribes, knives were made from flint, obsidian, and bison bones. The knife was a tool and weapon used in everyday life. During the fur trade era (1775–1840), Green River knives were traded throughout the northern Plains and Rockies. Some sheaths were made from harness leather inserted with brass tacks. Other sheaths were elaborately decorated with dyed porcupine quills and glass seed beads.*

Sioux knife

Sioux knife sheath

Flathead sheath

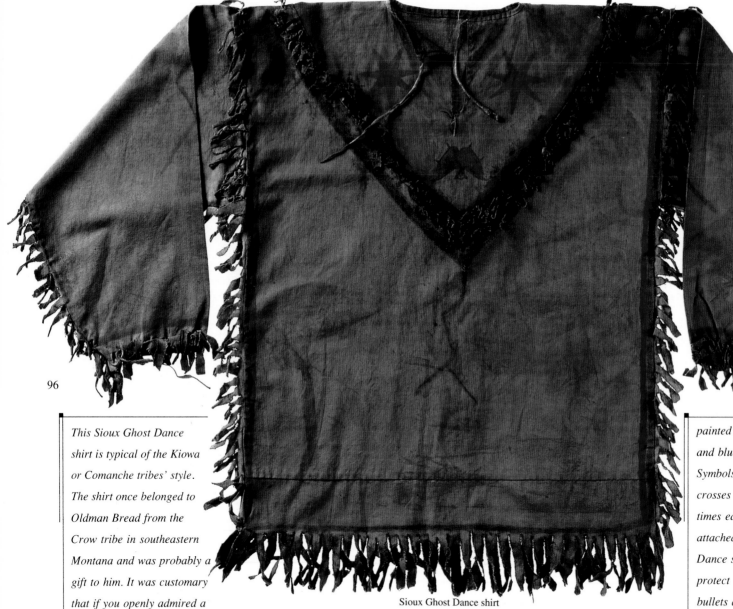

*This Sioux Ghost Dance shirt is typical of the Kiowa or Comanche tribes' style. The shirt once belonged to Oldman Bread from the Crow tribe in southeastern Montana and was probably a gift to him. It was customary that if you openly admired a person's possession, it would be given to you even if it was a prized possession such as a horse, bison robe, ermine skin, or any other valued object. If you were given a*

Sioux Ghost Dance shirt

*gift while visiting, a great honor was bestowed upon you. There was never an end to giving. Ghost Dance shirts were often made from muslin and decorated with muslin fringe. The shirts were*

*painted red to symbolize day, and blue to symbolize night. Symbols of moon, stars, and crosses were used; sometimes eagle feathers were attached (opposite). A Ghost Dance shirt was believed to protect its wearer from bullets and weapons. It was the Ghost Dance, a spiritual and religious ritual so feared by the soldiers, that led to the murder of Chief Sitting Bull and eventually to the slaughter at Wounded Knee.*

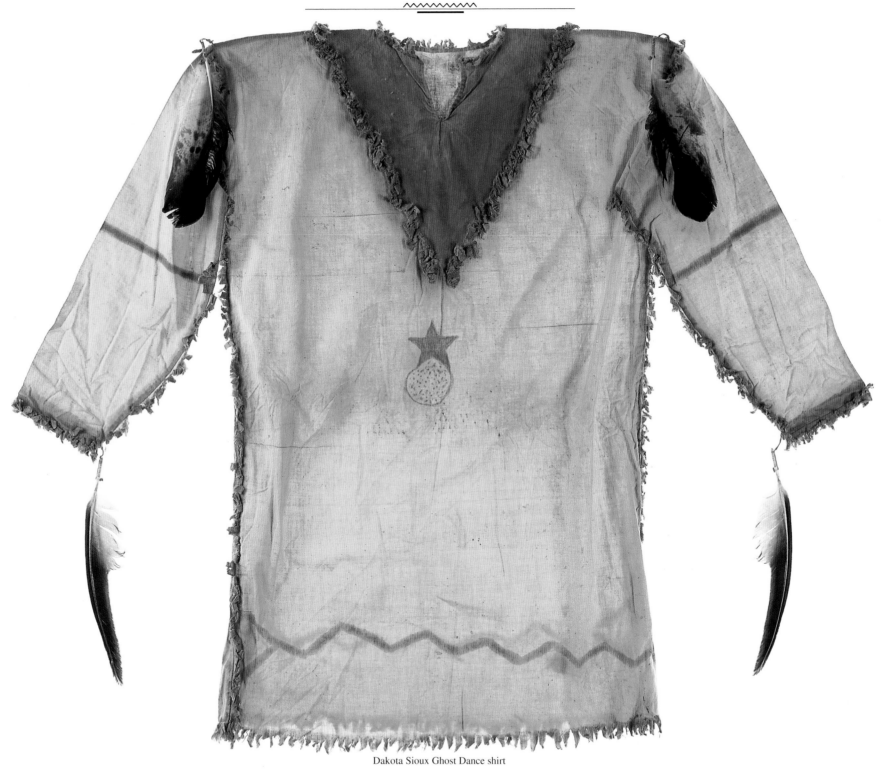

Dakota Sioux Ghost Dance shirt

# WOUNDED KNEE REMEMBERED

*Only the mountains
and hills live forever.*

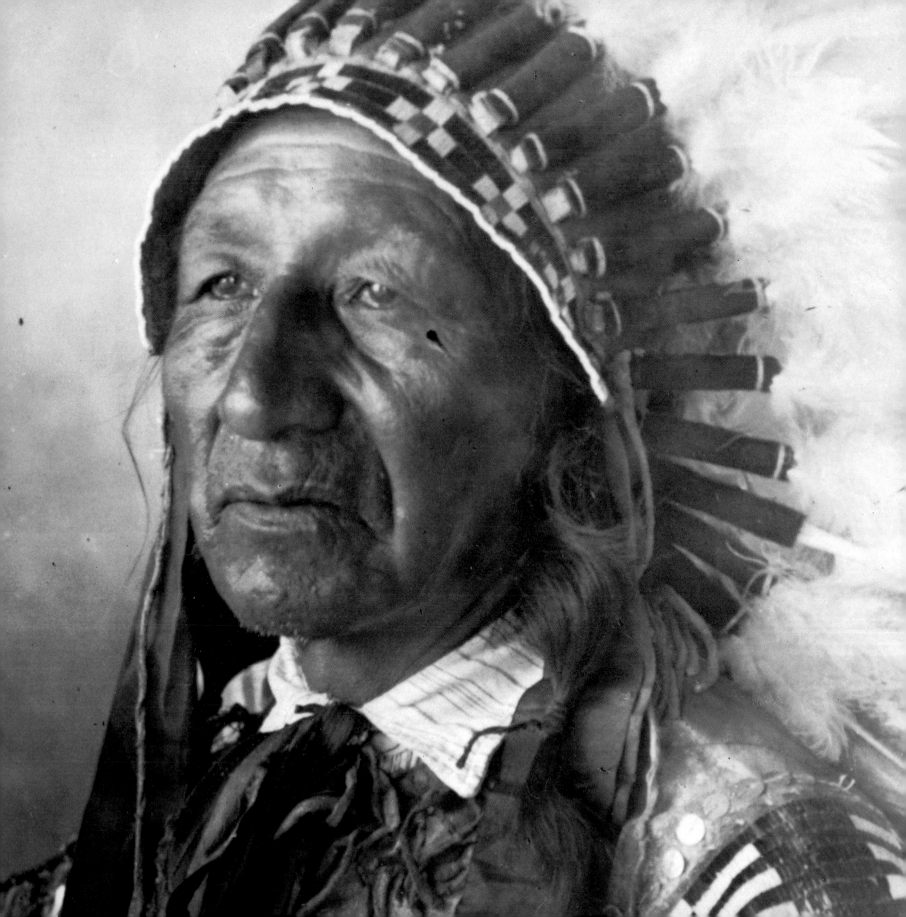

# WOUNDED KNEE REMEMBERED

*The buffalo were gone. The Indians had been moved to reservations, and were poverty-stricken. They knew the end was near. Their only hope was to turn to the Ghost Dance, a religious ritual to bring back the buffalo and the dead, and to make the white man disappear. The soldiers' fear of this dance led to the murder of Chief Sitting Bull of the Hunkpapa Sioux. Soon after that, Big Foot and his 350 people were massacred at Wounded Knee. This massacre ended all battles. All native religions were outlawed by the United States government. This marked the end of an era and the end of freedom. Dewey Beard, known as Iron Tail, told his granddaughter Celene Not Help Him of the horrifying massacre of his people at Wounded Knee in South Dakota on that cold winter day — December 29, 1890.*

I was raised by Dewey and Alice Beard after the death of my father. I remember these things [the Massacre], my grandfather told me to listen close and remember so that I can tell these things someday.

My grandfather Dewey Beard, also known as Iron Tail, Wasee Maza. He was the Last Survivor of Little Bighorn and also of the 1890 Wounded Knee Massacre. At Wounded Knee he lost his father, mother, two brothers, a sister, his wife and son. He and his four brothers, Joseph Horn Cloud, Daniel White Lance, Frank Horn Cloud and Earnest Horn Cloud, survived.

My grandfather was 27 years old at the time of the Wounded Knee Massacre, he died in 1956 at the age of 98. His father, Horn Cloud, was one of the six to be killed with Chief Big Foot. His mother, Brown Leaf Woman,

*Fast Horse of the
Oglala Sioux tribe.*

was shot from the back into the stomach and killed. His sister, Pretty Enemy, was among the ones shot in the ravine. His two brothers, William and Sherman, his wife, Wears Eagle, were shot in the breast, and his son, Wet Feet, was found with his mother, still alive, nursing on his dead mother—he died later.

He said, "The day before we were tired and cold and hungry. When we ran away from Standing Rock, after they killed Sitting Bull, we don't eat that good and we don't sleep that good.

"We made a short stop at Red Water Creek. We built a fire to make some tea for Chief Big Foot. He drank a little bit, but he said he didn't feel like eating, he was really sick." They started out and camped at Red Elk Springs. That's where they spent the overnight.

"By noon we packed everything up and headed out for Pine Ridge. We got to Porcupine Butte. Just then, two of the scouts came back and said 'Alert' or get ready for trouble because we spotted some horseback riders. They were white soldiers and Indians.

"A white man came over and talked to Big Foot. 'Are you Big Foot? We're looking for you,' said the soldier. 'Can you talk?' They asked him, 'When we get to Pine Ridge we want you to put down 25 guns.' He [Big Foot] said he could do that." All the soldiers came down around them and then, there was two wagons that came along. It looked like they were really heavy, he said. "Some more came and just before we got to Wounded Knee we got the news that there were Hotchkiss guns all around them, two on each side." They surrendered and the soldiers took them to Wounded Knee.

The soldier said that they were going to camp there overnight. He said "After you put up your tipi and get ready, we will give you rations." Since Big Foot was really sick, he agreed to stop there for the night. So, they all got their rations and built fires and were cooking. After they ate, that's when they told Grandpa Horn Cloud to go to Big Foot's tent.

"This is what I remember. Someone tapped on the tipi door. An Indian soldier [scout] peeked in. 'After you get done, I want you to go to where Big

Foot is staying.'" He [my grandfather] got his coat on and went out, going towards where Big Foot's tent was.

On the way a white soldier started to push him around really mean. He turned around and looked up at the white soldier. Then he remembered what Big Foot had told him, to be humble.

When Big Foot told Grandpa Horn Cloud that, he said that he could barely hear him. Big Foot was sick with pneumonia. When he passed the Badlands, he started to have a hemorrhage. He lost a lot of blood. He was really getting sick. He told them not to start any trouble. He said there were lots of children and lots of old people, there were more women than men, so he asked that they be humble. "Humble yourself," he said.

He [Grandfather] remembered that as he was walking, he [the white soldier] said something to him in English, he didn't understand and asked one of the Indian soldiers what he said. "Don't pay any attention to him," the Indian soldier said. He [my grandfather] went into Big Foot's tent and Big Foot was glad to see him. He said, "Good you came over. That's good, come and sit down." Already Iron Eyes, Spotted Thunder and a few others were there. There were six of them all together and they started talking.

Just then, my grandfather's little brother, Joe Horn Cloud Jr., came in. Grandmother Big Foot told Joe, "Can you go and tell one of the soldiers to fix along the bottom of the tent? It's really cold. They've got a really big stove in here, but I think it [the tent] is about two feet off the ground."

Grandpa Beard told me, "They wouldn't let us go to sleep. All night they tortured us by gunpoint. They asked us who all was in the Battle of Little Big Horn, the battle with Custer. We can't tell anything—so we told them we don't know. They were saying things to us in English, but we can't tell them what we don't know. Besides, the interpreter is not that good," he said. "Maybe he tells them something else or is afraid to say anything.

"One of the six men sitting there almost went to sleep, that's when the soldier poked him really hard with his gunbarrel. We all looked and we didn't

like how they treated him, but he said remember be humble. So, he told us not to sleep.

"The next morning we went back to our tents and ate. They [the soldiers] called for a meeting. They said, 'All of you get out and go to the center and bring your guns. Do it fast so that when you get done, we'll head out to Pine Ridge.'"

Joe Horn Cloud Jr. said he went to talk to his grandfather and was coming back when one of the white soldiers said, "Little boy, you're too little to be out here. Go back to your tent and stay with your mother. All of these soldiers have hot stomachs."

Then a guy came along, his name was Black Hawk. He can't hear good but he could talk. He pointed out at his gun in the area. He said, "Look at my gun. Ever since I got it, I don't shoot two-leggeds. I only shoot four-leggeds to feed my family. I hate to part with it. It's the only way I feed my family."

Then he [Grandfather] said, down where the soldiers were staying around, a voice came from there and their flag went down and they started firing. While the firing was going on, Grandfather stood up and run to where his father and Big Foot was.

He said they were they first ones to die. One leaned sideways, the other had his face down. He saw it was no use and he went back to the tipi and ran to his wife. There was no one there at the camp. His horses were running around. Some were still tied down and were pulling hard. He was standing there when he saw a man. He was trying to say brother-in-law. He was shot and his jaw was hanging. He was trying to talk but his tongue was hanging too. He was trying to get help for his wife.

He helped him to take her to the dry creek towards the west. He said he didn't know what happened to her. He kept running.

He saw a woman holding up her shawl like it could be a shield against the bullets. He thought he saw a black cloth hanging in front of her, and then he realized it was her braids, shot off and was hanging loose in front of her.

He saw a mother, with a baby in her arms. He took the baby, "Come on let me help you." He saw a woman, she took the baby and lay down on it and played dead. He kept on going, he saw his brother Daniel who called for him to stop. His brother was limping he went to help him.

He saw his mother standing and singing she was waving a pistol, she told him to take it, she was dying. He cried and helped her sit down. He kept going, he was getting dizzy so he sat down. He felt like he couldn't get up he looked down and saw he had been shot again, in the lap.

My grandfather was shot in the back, it went through to his lung in the first volleys of gunfire. He was again shot in the right calf and in the hip. He was coughing blood. He had lost a lot of blood, he could hear someone singing a death song. Whenever someone moved, the soldiers shot them.

"I was badly wounded and pretty weak too. While I was lying on my back, I looked down the ravine and saw a lot of women coming up and crying. When I saw these women, girls and little girls and boys coming up, I saw soldiers on both sides of the ravine shoot at them until they had killed every one of them," said Dewey Beard in his testimonial on the massacre.

Beard ran to the hills with other band members to escape the shooting. He went into the hills and sang a death song for Chief Big Foot.

He was covered with frozen blood. He saw some men on horseback he thought were soldiers. They said *Kola*, friend, are you Indian? He said "Yes, I'm Indian." They asked him what he was doing, he told them he was dying. They told him he was not going to die, and took him to a farmhouse and built a fire and gave him a set of their clothes so he could change from the clothes frozen to his wounds. The wound on his lung started to bleed, they dressed it the best they could and went on to Pine Ridge Agency.

They took him to Alex Merrival's cabin. He was an uncle of my grandfather. He and his wife were crying, they already had 21 people in the house, other people who had escaped the massacre.

I would like to tell you one thing. In the Indian way, men and their mother-in-laws never speak to each other. They did this out of deep respect. When those soldiers buried everyone they killed, men women and children, in a mass grave, they showed no respect, not for them or their beliefs.

They just threw them in there any old way, just so their frozen bodies would fit. My grandfather told me that one man was wounded, he would have lived if they got him help, but they buried him anyway. Even a boy and a baby were buried alive by them soldiers.

———

The above are excerpts from statements by Celene Not Help Him, a Wounded Knee Survivor Descendant presented at the September 25, 1990, hearing before the Senate Select Committee on Indian Affairs.

From "A Descendent Relates Her Grandfather's Version," printed in *The Lakota Times*, January 8, 1991. Reprinted with permission from Celene Not Help Him.

*Old Cheyenne warrior.*

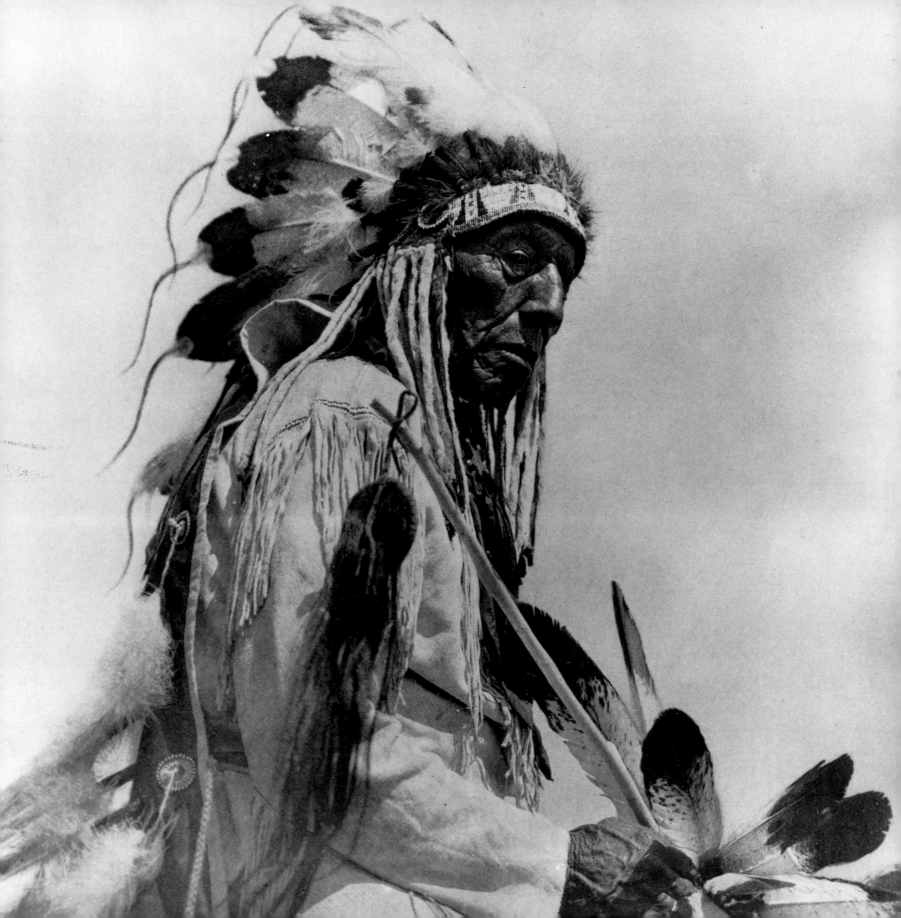

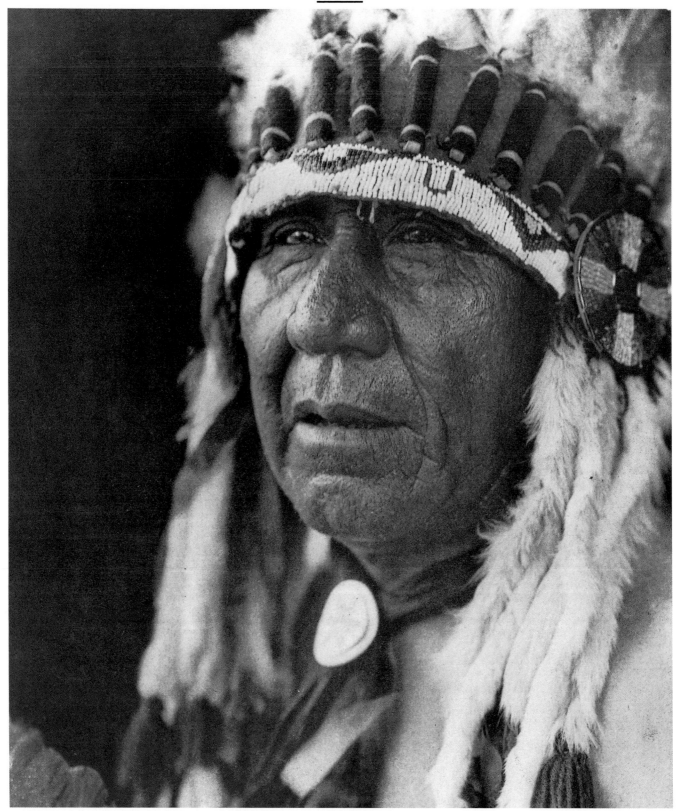

*WaKónda, Oto.*

We are all part of the cycle of life. My Indian ancestors respected their relationship with the water, fire, earth, and sky in their everyday lives.

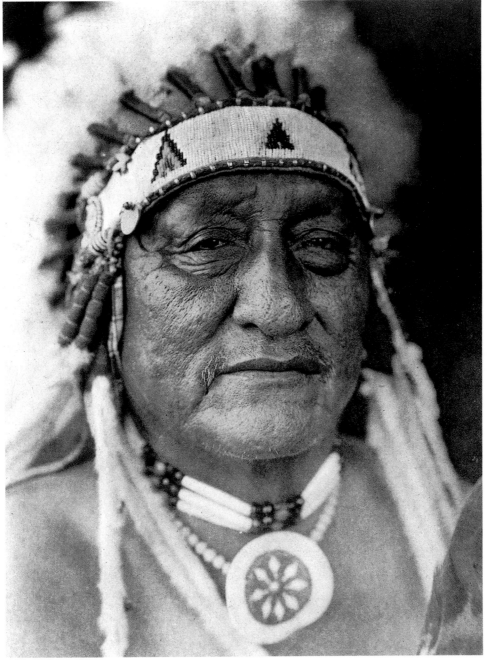

*Standing Two, Oto.*

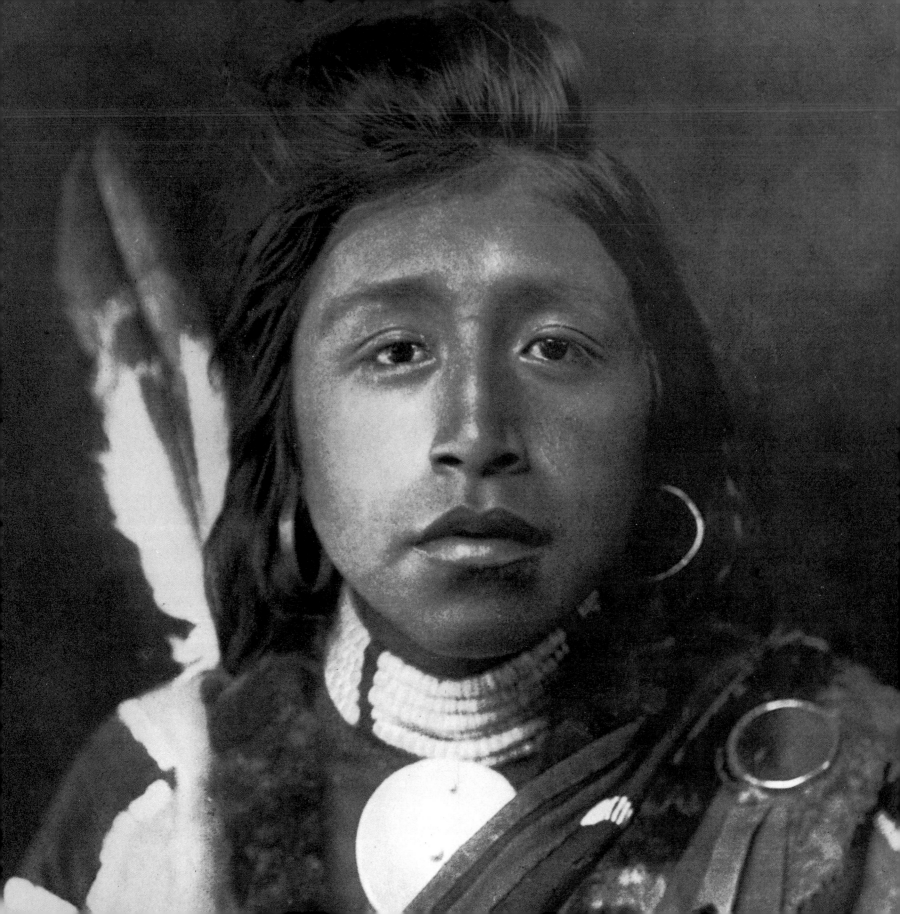

> Fire, I call my grandfather. He represents wisdom. He has been burning since the beginning of time.

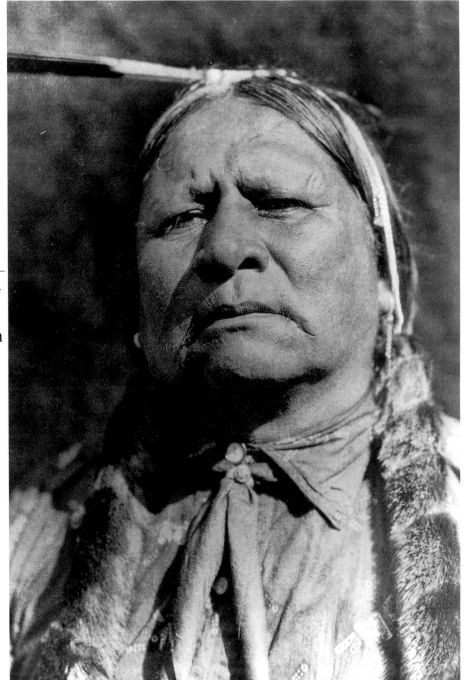

*Walter Ross, Wichita.*

*Kashhila, Wisham tribe.*

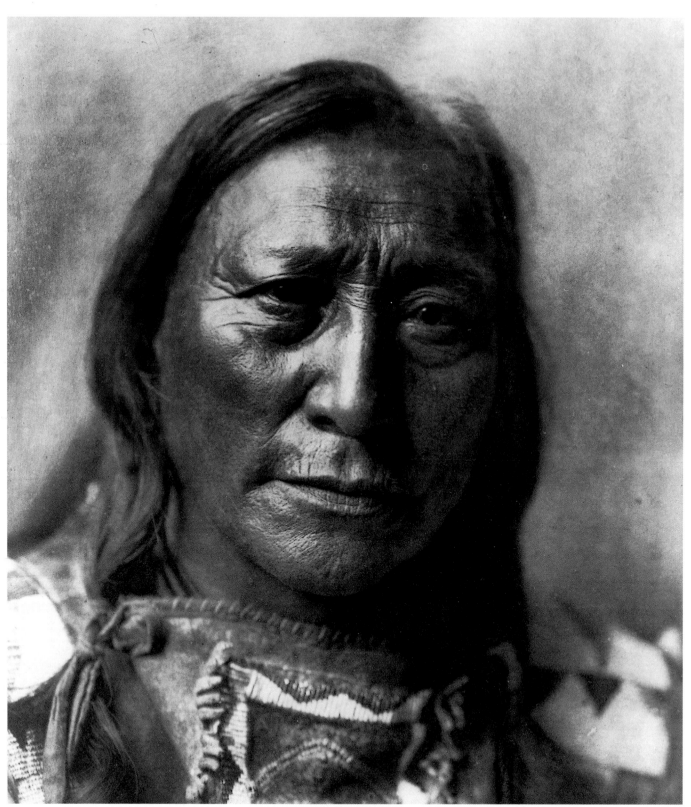

*Hollow Horn Bear, Brulé.*

From the old men of different tribes I have learned respect for Mother Earth. These men are my grandfathers. They taught me to take what was needed from Mother Earth and to always leave an offering of tobacco to show reverence for her.

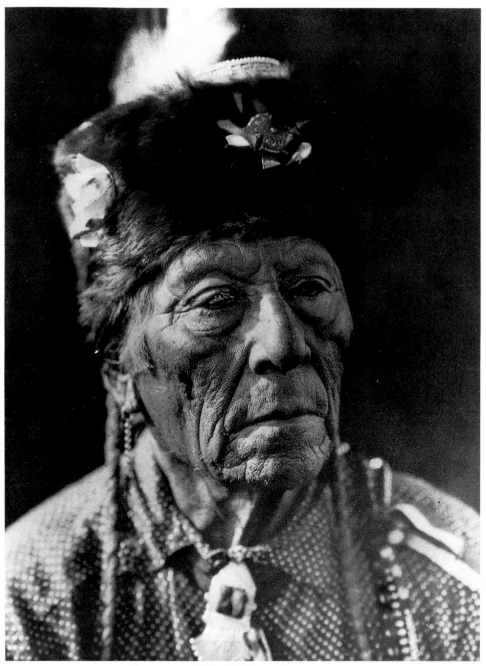

*Lefthand, Comanche.*

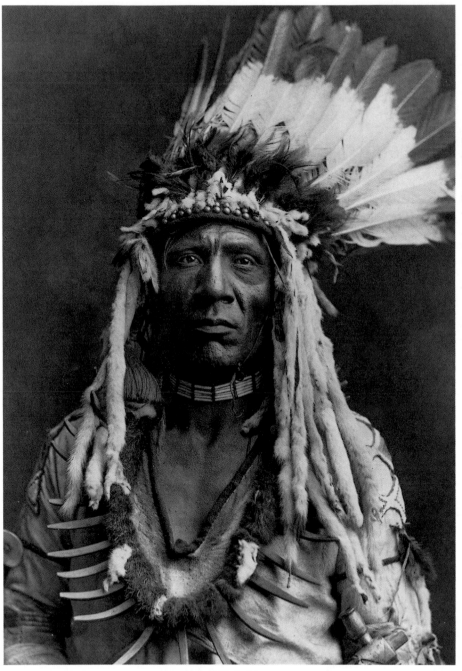

*Weasel Tail, Piegan.*

My grandfathers and grandmothers have given back their bodies to our mother the earth and have journeyed over the spirit trail beyond the setting sun. In this way, they have given back their souls to our father, the sky. Their words of wisdom are a legacy that will continue to live through generations to come.

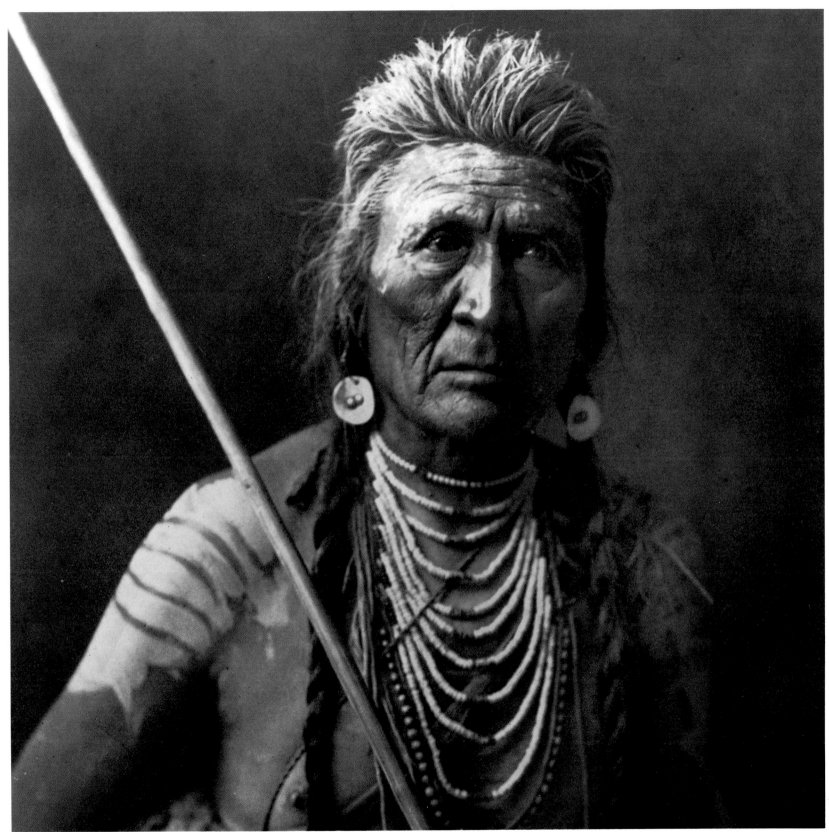

*Wolf, Apsaroke.*

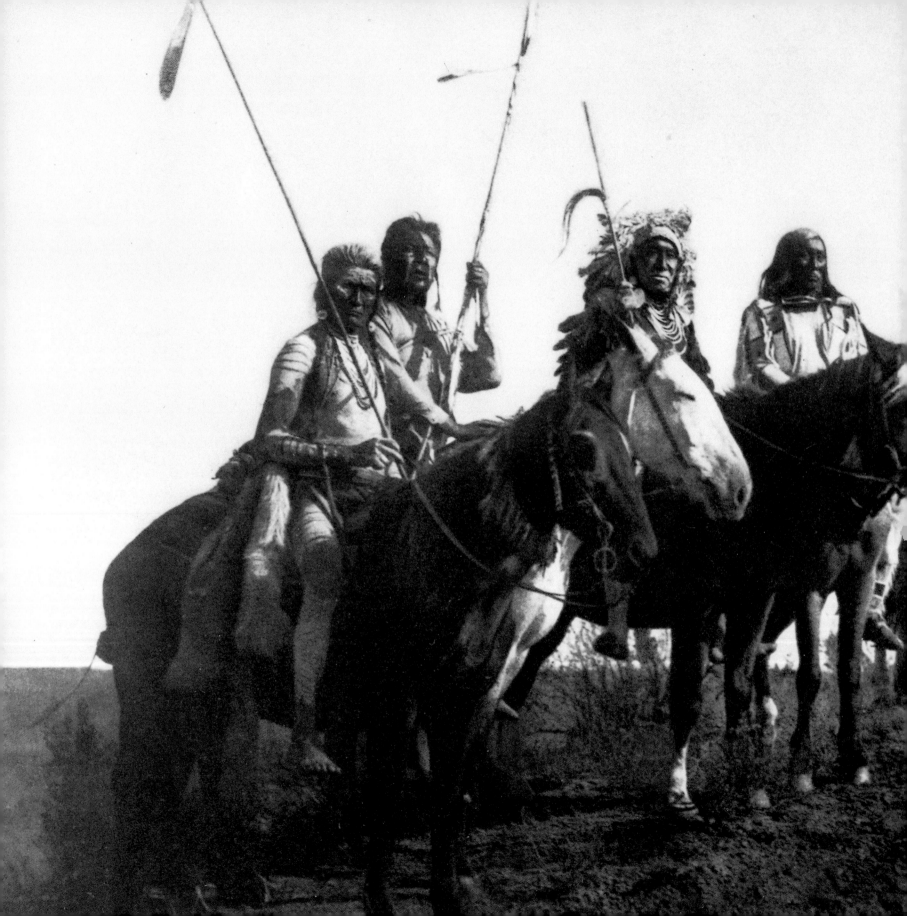

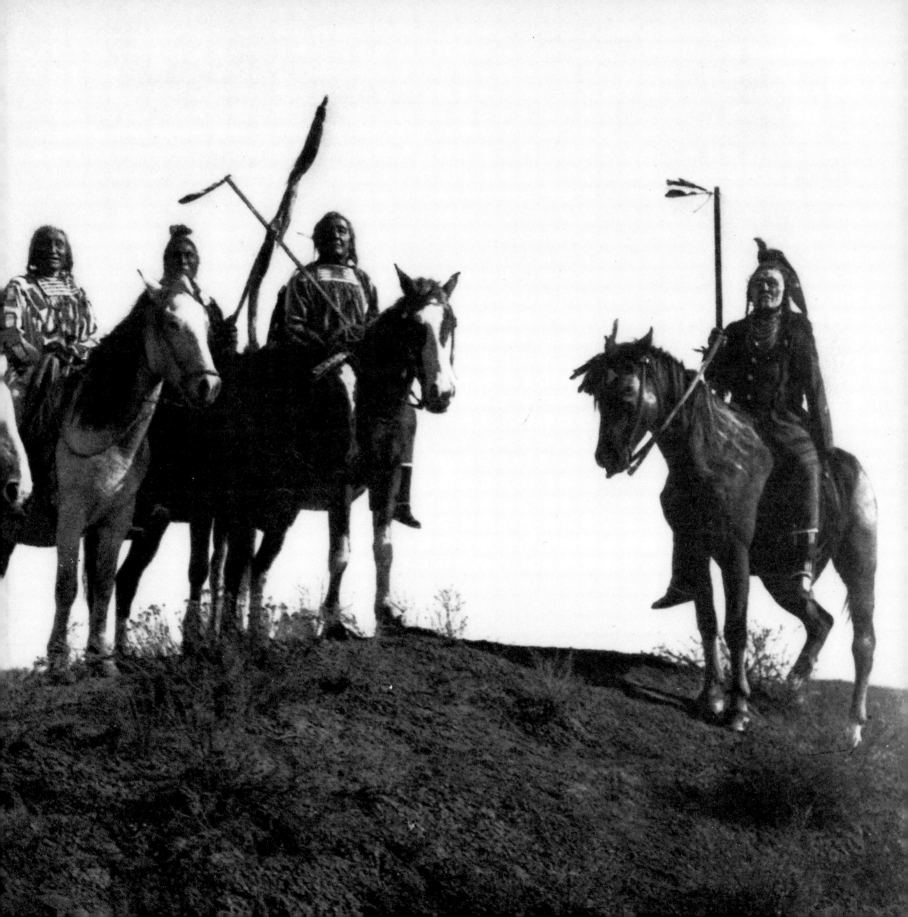

118

| Page | Museum | Identification |
|---|---|---|
| | | **1978-71-41**; split-horn bonnet, *Blackfoot*, late 1800s |
| | | **J4695**; quirt, *Crow*, ca. 1900 |
| 84 | SDMM | **2881**; breastplate, *Sioux*, ca. 1890 |
| | | **11331**; whip (quirt) made of an antler, *Plains Indian*, date unknown |
| | | **15377**; club (coupstick), *Blackfoot*, ca. 1894 |
| | | **1979-7-1 b**; drum and drum beater, *Chippewa*, ca. 1910 |
| 85 | SDMM | **3935**; necklace, *Plains Indian*, date unknown |
| | | **4898**; war drum, *Sioux/Cheyenne*, ca. 1876 |
| | | **1967-46-12**; roach, *Blackfoot*, late 1800s or early 1900s |
| | | **1978-68-15 e**; arrow, *Navajo*, ca. 1913 |
| | | **J913**; arrow, *Sioux*, date unknown |
| | | **J922 b**; bow, *Osage*, date unknown |
| 86–87 | CBIAM | **5228**; war shirt, *Crow*, ca. 1880 |
| 88–89 | SDMM | **1982-11-1**, ledger drawing, *Cheyenne*, late 1880s |
| 90 | CBIAM | **5440**; beads and scalp lock, *Crow*, ca. 1900 |
| | | **5594**; quirt, *Prairie Sioux*, ca. 1875–1900 |
| | | **5778**; quirt, *Blackfoot*, ca. 1875–1900 |
| | | **6243**; war club, *Winnebago*, ca. 1875–1900 |
| 91 | CBIAM | **1649**; arrow, *Plains Indian*, ca. 1875–1900 |
| | | **1650**; arrow, *Plains Indian*, ca. 1875–1900 |
| | | **1651**; arrow, *Plains Indian*, ca. 1875–1900 |
| | | **1652**; arrow, *Plains Indian*, ca. 1875–1900 |
| | | **5234**; bow and arrow quiver case, *Sioux*, ca. 1890 |
| | | **5544**; scalp and shield, *Crow*, ca. 1875–1900 |

| Page | Museum | Identification |
|---|---|---|
| 92–93 | SDMM | **10687**; war flag, *Mojave*, date unknown |
| | | **25472**; arrow, *Diegueño*, date unknown |
| | | **J121**; arrow, *Yahi*, date unknown |
| | | **J965**; arrow, *Sioux*, date unknown |
| | | **J4309**; bow, *Sioux*, date unknown |
| 94 | CBIAM | **5274 a**; knife, *Plains Ojibwa*, ca. 1890 |
| | | **5281 b**; knife scabbard, *Sioux*, ca. 1900 |
| | | **5291 b**; sheath, *Flathead*, ca. 1880 |
| | | **6069**; sheath, *Sioux*, ca. 1875–1900 |
| 95 | CBIAM | **5070**; sheath, *Sioux*, ca. 1875–1900 |
| | | **5278 a**; knife, *Sioux*, ca. 1875–1900 |
| | | **5288 b**; sheath, *Flathead*, ca. 1875–1900 |
| 96 | SDMM | **11500**; Ghost Dance shirt, *Sioux*, date unknown |
| 97 | SDMM | **6163**; Ghost Dance shirt, *Dakota Sioux*, ca. 1890 |

Photo credits:

Page 7, *Brulé Warriors—Teton Sioux,* Edward S. Curtis, courtesy of San Diego Museum of Man.
Page 9, Buffalo skull, John Oldenkamp, courtesy of Chris Bentley.
Page 10–11, Burial, Roland Reed, courtesy of San Diego Museum of Man.
Page 18, Presque Isle River, Porcupine Mountain Wilderness State Park, Michigan, Willard Clay.
Page 20, *A Medicine Pipe—Piegan,* Edward S. Curtis, courtesy of San Diego Museum of Man.
Page 25, *A Flathead Dance,* Edward S. Curtis, courtesy of San Diego Museum of Man.
Page 28–29, Montana, John Oldenkamp.
Page 30, Dinosaur National Monument, Colorado, Willard Clay.
Page 32, Yellowstone National Park, Wyoming, John Oldenkamp.

Page 50, Snake River, Grand Teton National Park, Wyoming, Willard Clay.
Page 52, *Planning a Raid,* Edward S. Curtis, courtesy of San Diego Museum of Man.
Page 68, Little Bighorn River, Montana, John Oldenkamp.
Page 70, *On the Little Bighorn—Apsaroke,* Edward S. Curtis, courtesy of San Diego Museum of Man.
Page 75, *A Burial Platform—Apsaroke,* Edward S. Curtis, courtesy of San Diego Museum of Man.
Page 89–87, Jerry Jacka, courtesy of Colter Bay Indian Arts Museum.
Page 98, Mount Baker, Washington, Pat O'Hara.
Page 100, *Fast Horse—Sioux,* Julia E. Tuell, courtesy of San Diego Museum of Man.
Page 107, *The Old Cheyenne,* Edward S. Curtis, courtesy of San Diego Museum of Man.
Page 108, *WaKónda—Oto,* Edward S. Curtis, courtesy of San Diego Museum of Man.
Page 109, *Standing Two—Oto,* Edward S. Curtis, courtesy of San Diego Museum of Man.
Page 110, *Kashhila—Wishham,* Edward S. Curtis, courtesy of San Diego Museum of Man.
Page 111, *Walter Ross—Wichita,* Edward S. Curtis, courtesy of San Diego Museum of Man.
Page 112, *Hollow Horn Bear,* Edward S. Curtis, courtesy of San Diego Museum of Man.
Page 113, *Lefthand—Comanche,* Edward S. Curtis, courtesy of San Diego Museum of Man.
Page 114, *Weasel Tail—Piegan,* Edward S. Curtis, courtesy of San Diego Museum of Man.
Page 115, *Wolf—Apsaroke,* Edward S. Curtis, courtesy of San Diego Museum of Man.
Page 116–117, *Watching for the Signal—Apsaroke,* Edward S. Curtis, courtesy of San Diego Museum of Man.

For further information, contact the museums at the addresses listed below:

Colter Bay Indian Arts Museum
Colter Bay Visitor Center
Grand Teton National Park, Wyoming 83012

San Diego Museum of Man
1350 El Prado, Balboa Park
San Diego, California 92101

BIBLIOGRAPHY

Akwesasne Notes. *A Basic Call to Consciousness*. New York: Akwesasne Notes, 1978.

Armstrong, Virginia. *I Have Spoken: American History Through the Voices of the Indians*.

Chicago: The Swallow Press, 1971.

Beck, Peggy V., and Anna L. Walters. *The Sacred: Ways of Knowledge, Sources of Life*. Tsaile, Ariz.: Navajo Community College Press, 1977.

Black Elk. *The Sacred Pipe: Black Elk's Account of the Seven Rites of the Oglala Sioux*. Edited by Joseph Epes Brown. Norman: University of Oklahoma Press, 1953.

Brown, Dee. *Bury My Heart at Wounded Knee*. New York, Chicago, San Francisco: Holt, Rinehart, and Winston, 1977.

Brown, Joseph E. *The Spiritual Legacy of the American Indian*. New York: Crossroads Publishing Company, 1986.

Davis, Barbara A. *Edward S. Curtis: The Life and Times of a Shadow Catcher*. San Francisco: Chronicle Books, 1985.

Densmore, Frances. *Teton Sioux Music*. Bulletin no. 61. Washington, D.C.: Bureau of American Ethnology, 1918.

Farr, William E. *The Reservation Blackfeet 1882–1945, A Photographic History of Survival*. Seattle and London: University of Washington Press, 1984.

Gard, Wayne. *The Great Buffalo Hunt*. Lincoln and London: University of Nebraska Press, 1968.

Hoig, Stan. *The Sand Creek Massacre*. Norman: University of Oklahoma Press, 1961.

Houlihan, Patrick, Jerold L. Collings, Sarah Nestor, and Jonathan Batkin. *Harmony by Hand: Art of the Southwest Indians*. San Francisco: Chronicle Books, 1987.

Howard, Helen Addison. *Saga of Chief Joseph*. Caldwell: The Caxton Printers, Ltd., 1971.

Hungry Wolf, Adolf. *Children of the Sun*. New York: William Morrow and Company, Inc., 1987

Hungry Wolf, Beverly. *The Ways of My Grandmothers*. New York: William Morrow and Company, Inc., 1980.

Hyde, George. *Red Clouds Folks: A History of the Oglala Sioux*. Norman: University of Oklahoma Press, 1937.

Jones, Douglas C. *The Treaty of Medicine Lodge*. Norman: University of Oklahoma Press, 1966.

Josephy, Alvin M., Jr. *The Nez Perce Indians and the Opening of the Northwest*. New Haven and London: Yale University Press, 1965.

Kroeber, Theodora. *Ishi*. Berkeley and Los Angeles: University of California Press, 1964.

Laubin, Reginald and Gladys. *The Indian Tipi: Its History, Construction and Use*. Norman: University of Oklahoma Press, 1984.

Lowie, Robert H. *The Crow Indians*. Lincoln and London: University of Nebraska Press, 1963.

Lyford, Carrie A. *Quill and Beadwork of the Western Sioux*. Boulder: Johnson Publishing, 1990.

Marriott, Alice. *The Ten Grandmothers*. Norman: University of Oklahoma Press, 1977.

McLuhan, T.C. *Touch the Earth: A Self-Portrait of Indian Existence*. New York: Outerbridge and Lazard, 1971: Simon and Schuster, Pocket Books, 1972.

Miller, David Humphrey. *The Ghost Dance*. New York: Van Rees Press, 1959.

Neihardt, John G. *Black Elk Speaks*. Lincoln and London: University of Nebraska Press, 1989.

Nevin, David. *The Soldiers*. New York: Time-Life Books, 1973.

Niethammer, Carolyn. *Daughters of the Earth: The Lives and Legends of American Indian Women*. London: Collier MacMillian Publishers, 1977.

Rockwell, David. *Give Voice to Bear: North American Indian Myths, Rituals and Images of the Bear*. Niwot: Robert Rinehart Publishers, 1990.

Roe, Frank Gilbert. *The Indian and The Horse*. Norman: University of Oklahoma Press, 1974.

Stewart, Omer C. *Peyote Religion: A History*. Norman and London: University of Oklahoma Press, 1990.

Trenholm, Virginia Cole, and Maurine Carley. *The Shoshoni's Sentinels of the Rockies*. Norman: University of Oklahoma Press, 1964.

Vestal, Stanley. *Sitting Bull: Champion of the Sioux*. New York: Houghton Mifflin, 1932.

Voget, Fred W. *The Shoshoni-Crow Sun Dance*. Norman: University of Oklahoma Press, 1984.

Walters, Anna Lee. *The Spirit of Native America: Beauty and Mysticism in American Indian Art*. San Francisco: Chronicle Books, 1989.

120